VISIONA

♦

THE LIFE OF CHRISTINA OF MARKYATE

VISIONARY WOMEN

Also in this series:

THE TRAVELS OF EGERIA
Karen Armstrong

FLORENCE NIGHTINGALE: LETTERS AND REFLECTIONS
Rosemary Hartill

EMMA LAZARUS
Emma Klein

THE MARTYRDOM OF PERPETUA
Sara Maitland

THE TRIAL OF JOAN OF ARC
Marina Warner

Other titles in preparation

VISIONARY WOMEN

Series editor: Monica Furlong

THE LIFE
OF
CHRISTINA
OF
MARKYATE

translated by

MONICA FURLONG

with an introduction and commentary

ARTHUR JAMES

BERKHAMSTED

First published in Great Britain in 1997 by

ARTHUR JAMES LTD
70 Cross Oak Road
Berkhamsted
Hertfordshire HP4 3HZ

ISBN 0 85305 351 0

Typeset in Monotype Sabon by
Strathmore Publishing Services, London N7

Printed and bound in Great Britain by
Guernsey Press Ltd, Guernsey, C.I.

Contents

Series Foreword *by Monica Furlong* 7

Introduction *by Monica Furlong* 11

Translator's Notes 27

THE LIFE OF CHRISTINA OF MARKYATE 29

Series Foreword

Women's vision of what life is about, or what it might become, has been neglected in the past. It is not that women are necessarily so very different from men. It is rather that, historically, their experience has been a very different one, and that this has important bearings on women's perspective and women's insight.

So our plan in the *Visionary Women* series is to seek out texts by or about women of vision, and to bring them to a wider audience. Some of our subjects will be famous, like Florence Nightingale or Joan of Arc – though we may discover very new ways of looking at such famous women as we bring new insights to bear on them. Other subjects will be almost entirely unknown, or known only by name, and it is our hope and pleasure to try to help readers to make new discoveries. We would be delighted if people decided to build a small library of these women writers and thinkers – overall we believe they offer new ways of thinking and seeing. We shall include spiritual writers, both Christian and other, as well as social reformers, politicians, and others through the ages who have engaged effectively or interestingly with the world whether outside them or within them.

Not all of our subjects are easy to read or understand, nor should they be read uncritically, since this is to patronise them. To help assess and interpret each of

our subjects, we have asked women writers to contribute an introduction to each volume.

Our overall aim is to allow the lost voices of women to speak. We long to break through the terrible silence of women that Christianity, explicitly, enjoined on them, but which non-Christian cultures have often imposed with equal effectiveness. We passionately want to know what sense women made of their lives in the long centuries when education was effectively denied to them, and when few of them could read or write. Within Christianity now there is a healthy remorse for all that was lost when women's voices were silenced, but, as if this is part of a worldwide movement, women in many different cultures now seem less willing to be silent and passive participants than in the past. There is movement, a hunger for women's knowledge and understanding. This series is a small attempt to meet that hunger.

MONICA FURLONG

CHRISTINA OF MARKYATE

INTRODUCTION

Introduction

Any text about the life of a woman in twelfth-century England is interesting for its rarity value, but this first-hand account of the dramatic adventures of one who eventually became a recluse is fascinating in its own right. It is an exciting story, it is profoundly revealing of medieval family life, and it has glimpses of 'high life' and the disturbing degree of corruption it contained – our author is not in the least surprised to find a famous bishop, 'taking second place in the State after the king', indulging in a little child molesting. It also takes us into the world of medieval religion, an odd mixture of credulity, superstition, and a very moving devotion, which it is not easy for a twentieth-century mind to interpret. Above all it shows us what her Christian belief meant to one woman – Christina of Markyate, c. 1096 to c. 1155/66 – and the extraordinary way in which, at great personal cost, it set her free to lead her own life.

On a different level the book also reveals something about the rather gossipy monk who tells the story. This is very useful. His style makes it clear to us that, for medieval people, stories of holy people and events were their form of adventure story, even perhaps a kind of soap opera. Readers who themselves led more conventional and humdrum lives enjoyed the suspense and drama of heroism, miracles, visions, sightings of the devil, and terrifying reversals of fortune. They certainly found them in Christina's life story.

We do not know the name of her biographer, only his

vocation as a monk at St Albans Abbey. Presumably she herself could not write, or did so with difficulty. The author of her life story admired her deeply and knew her very well. He knew her family, and listened to her mother describing the circumstances of her pregnancy and Christina's birth, and later he heard her sisters discussing her. He knew the life of St Albans Abbey, a place of very great significance for Christina, and people who were important to her – the abbot Geoffrey, the hermits Edwin and Roger and Alfwen, the canon Sueno. He knew, and enjoys repeating to us, the local gossip. He is a credulous fellow, though maybe not more so than many of his con-temporaries, who much enjoys 'signs and wonders', and he does not hesitate to use them to a didactic end. He is a misogynist at heart, who cannot really understand how a mere woman like Christina can be so 'manful', as he irri-tatingly describes her; and in the middle of describing the almost indescribable sufferings of his subject, he stops to complain how women worry about nothing at all. Worst of all, as a man of his time, he is not too surprised at the sexual and emotional pressures used against the adoles-cent Christina by her parents. He is indignant about the way they abuse her on the grounds that she is vowed to Christ, but not for the more fundamental reason that a young girl is being subjected to the most appalling cruel-ty, a cruelty of which bishops, the prior of St Albans, and other friends of her father thoroughly approve. Their con-cern is that Autti should not lose face, that daughters should be obedient no matter what, and that the church should not be involved in scandal. Although Christina has been compelled to a betrothal entirely against her will, most of her fathers in God think she must go through

with the marriage, and her biographer would probably concede that they have a point of view. Yet oddly this unknown writer gives a far better testimony of the goodness and greatness of Christina than he quite knows. He admires her in spite of his prejudices. In his own way he loved and cared about her, and obviously spent a great deal of time listening to her describing the events of her life – time and again we hear what can only be her authentic voice.

Christina, known as a child as Theodora, was the first child of a couple in Markyate – Beatrix and Autti, a family of 'ancient and influential English nobles' who were considerable landowners. Rather as Hilda of Whitby's mother had a dream while pregnant which prepared her for the idea that she was about to give birth to an unusual child, so Beatrix had an experience which seemed to her to mark out the character of her unborn child as one destined for a life of holiness. (It was a pity that, years later, she chose to forget this powerful happening, though the biographer, who makes much of the incident, never seems to notice the irony.) She

> looked out one day from her house towards the monastery of Our Lady which was situated in the town. And suddenly she saw a dove, whiter than snow, leave the monastery and come straight towards her in gentle flight; and with its wings folded, it took shelter in the sleeve of the tunic she was wearing. This occurred on a Saturday, a day specially set aside by the faithful for the devotion to the Mother of God. It was between the feasts of the Assumption and the Nativity of Our Lady. Furthermore, as she told me herself, the dove stayed quietly with her for seven whole days, allowing itself

to be stroked with her hands, showing no sign of uneasiness, and nestling comfortably and with evident pleasure first in her lap and then in her bosom.

A modern reader might put a different gloss on this from the one that this medieval writer did, assuming that a domesticated dove had lost its way and was glad to find a temporary home; but to Beatrix the meaning of the event was quite clear, particularly as it occurred between two feasts which celebrated the holiness of the Virgin Mary.

> Such a sign was evidently meant to convey that the child she was bearing would be filled with the Holy Spirit who hovered over Jesus in the form of a dove and who was described by the prophet Isaiah as being endowed with grace sevenfold. It showed also that she would be taught by the example and strengthened by the protection of Blessed Mary, ever a virgin, and be holy both in mind and body, detaching herself from the things of the world and finding peace in contemplation of the things that are above . . . As she considered the thing, she frequently gave it as her opinion that she would have such a child as would be very pleasing to God.

Whatever the spiritual content of the dove's visitation, it must have had another important consequence. Christina, who as a first child in a landed family might have felt her sex to be a disappointment to her parents, grew up with a sense, unusual for a girl, though one she shared with Hilda, that she was special in some way, singled out, valued. This had important implications later in her life when her parents unequivocally regarded her, a disobedient young woman, as a bitter disappointment and cross. Almost alone at times in her sense of her own

purpose in life and vocation, Christina showed phenomenal strength and confidence in resisting them.

Her life had begun happily in a comfortable household, with younger brothers and sisters as her companions. She was an attractive and pious little girl, with a touching habit of talking out loud to God when lying in bed at night, apparently under the impression that nobody else could hear what she said. She was mocked for this (the first of many times when Christina was to be ridiculed by her family), and immediately felt too inhibited to do it any more.

As a child she found a splendid ally in an elderly canon of Huntingdon called Sueno, who had a great fondness for her and encouraged her in her piety. As she grew up she confided to him her wish to be a nun, and he discussed with her, as he might have done with a grown up, the pros and cons of virginity. Despite the big age difference, each of them seemed to derive some spiritual solace from the other. Christina's parents, despite Beatrix's thoughts during her pregnancy, were worldly and unspiritual people, and she found in Sueno the parental understanding that was missing at home.

Christina's inclination for piety was strengthened and confirmed in a tiny moment that is one of the most moving in her life. On her birthday, maybe her twelfth, her parents took her to the shrine of St Alban, at St Albans Abbey. Immediately Christina felt a huge attraction to the pattern and style of life lived at the Abbey and knew that she wanted something similar for herself. With a precocious sense of vocation she made a little mark, a sign of the cross, with her finger on the doorway of the Abbey, as if claiming her part in the religious life, and she

expressed a wish to share in their fellowship. Perhaps she did not realize that she would never be permitted to join the monks. That night, when her parents, having fulfilled their religious duty, had a riotous party with their friends in the village of Shillington on the journey home, Christina kept apart, overwhelmed by the emotions of the day. The following morning at Mass, after the Gospel, she approached the altar, giving the priest a penny, as a symbol of surrendering herself. Her request was that, if she lived her life as a virgin, God would make her anew, in the image of His Son. It was as if this offering, together with the moment the day before when she had made the mark on the door of the Abbey, were her first religious vows. She certainly regarded them as such.

This was unfortunate for her parents who, apparently unaware of the profound inner step taken by their daughter, began to think eagerly of a marriage for her which would prosper their business and landowning prospects. Meanwhile, she had confided the events at St Albans to Sueno.

Then comes an event shocking to the modern mind (though common enough still for all that) – one which was to be repeated in different forms in poor Christina's life several times in the years which followed. Ralph, bishop of Durham, who was a friend of her father's, and a relative by marriage, was attracted by the little girl, whom she met by chance at her aunt's house.

While her parents were drinking in the hall, the bishop had Christina, possibly twelve, certainly no more than thirteen or fourteen, brought to his apartment, where he tried to seduce her. There is no knowing whether her parents knew about this, though on later evidence it seems

that Autti might have turned a cynical blind eye to it. Ralph was an important friend. On a pretext of bolting the door to secure Ralph and herself from interruption, Christina slipped away, thus turning Ralph, who felt insulted, into a dangerous enemy. Later he was to try to bribe her with a present of a silk dress. When that didn't work, he produced a young man, Burthred, whom he was determined Christina should marry. The biographer regards this later development as a determination to spoil Christina's virginity, by any means in his power, but it seems more likely that it was an act of friendship towards Autti. Burthred was a prosperous match, and Autti would be gratified by the union.

Christina was devastated at the suggestion of marriage, especially when Burthred called and tried to arrange a betrothal. 'I wish to remain single,' Christina simply said, 'because I have made a vow of virginity.' Beatrix and Autti thought at first that this was exquisitely ludicrous, and proceeded to make wedding plans. They bribed and threatened Christina, and tried to persuade a friend of hers, Helisen, to talk artlessly about the joys of marriage. This horrible disagreement dragged on with every possible pressure being applied, and after about a year, Christina suddenly broke down, and gave her consent to an espousal to Burthred. (Subsequent discussions about the espousal show that it was regarded as a quasi-marriage – a vow almost as unbreakable as marriage itself. The parties concerned are often referred to as if they are a married couple.)

Immediately she was appalled at what she had done and said that she would never permit sexual intercourse with Burthred. When presents and promises did not

work, Autti and Beatrix used the full force of medieval parental power on their poor daughter, shutting her up, and even refusing to allow her to visit the monastery which was her chief spiritual solace. Instead, they took her to every kind of worldly entertainment in the hope that she would learn what she was missing by giving all this up, and arranged for her to be cup-bearer at an important merchants' festival, the Gild Fair, which was regarded as a great honour. The cup-bearer was always a pretty girl who was loaded with compliments, and flirted with in the course of the day, an honour for which Christina was scarcely in the mood.

Beatrix and Autti, who little understood their wayward child, seemed to think she would get drunk on this occasion, and forget herself in some way that would give them a hold over her. Far from it, of course. Christina prayed her way through the day, and drank nothing but water.

Unforgivably, they thought that they would subvert Christina's wishes by letting Burthred into her chamber at night, so that, whatever she felt about it, she would lose her virginity, and so be unable to refuse marriage. Burthred, artlessly going along with this plan, found Christina up and fully dressed. She welcomed him as if he had been her brother, and politely explained to him how she could not sleep with him, that although their espousal gave them the status of a married couple, they would be obliged to live in chastity together. And she recited to him stories of other chaste couples. This sober conversation took the greater part of the night, and Burthred seems to have been more than a little intimidated by the powerful girl he had hoped to seduce.

Predictably, his friends, who waited eagerly to hear

about his progress, told him he was spineless and lacking in manly qualities. If he could not manage her by himself, they were ready enough to give him a hand. Then follows a truly horrible account by the biographer (all the more horrible since he does not find it a whit surprising), of an attempt to rape Christina set up by Burthred and his friends, in which, somehow anticipating their arrival, she hid behind the tapestry and hung there 'trembling'. Dodging rape on this occasion, she was then once again waylaid by Burthred and his friends; this time she managed to run away. To all this her parents were willing accomplices, and went ahead with the wedding preparations, as if there were no problem.

They can scarcely have felt things were going well with them, however, since in desperation Autti went to see Fredebert, the prior of St Albans, and made him a speech which the biographer, with his usual dramatic skill, reports very convincingly. It is an extraordinary blend of self-righteousness and hurt male pride. What is the world coming to, Autti wants to know, if girls start having ideas of their own about how they want to live their lives, and think they know better than their father what is best for them? In any case, if he lets Christina have her own way in this matter, everyone will laugh at him, and that is a very serious matter!

Fredebert takes Autti's side, and tells Christina that she is either impossibly obstinate or mad. She has been betrothed, after all, according to ecclesiastical custom, and this rite cannot now be reversed, so she had better get on with getting married. The woman has no power over her own body, he reminds her, paraphrasing St Paul (1 Corinthians 7:4), but the husband does. He also

commands her to show respect to her parents and instructs her to proceed with the marriage. It is a typical speech of 'authority' confronted with subversion. It is not so much that Fredebert is on Autti's side, as that he wants to get the 'nonsense' stopped, and fathers and daughters returned to their proper place in society.

Christina, standing there before the prior and canons of St Albans, for whom she has a tremendous respect, then makes the sort of moving speech that Joan of Arc would one day make at her trial, devastating in its truth and simplicity. She points out gently that she was espoused entirely against her will, that she never wanted to marry, and that from her childhood she had been vowed to virginity. There are witnesses to this fact, but, in any case, God knows that it was what she promised. Is it not wicked of her parents to suggest that she should abandon this promise and marry? She will not judge the matter, but she leaves it to the monks to do so. She is not trying to be disobedient to her parents, but rather to be obedient to her promise to Christ.

Fredebert is 'astonished' by this speech, but responds to it with a sickening and contemptuous cynicism. Intolerably he suggests that Burthred is not rich enough for Christina, and that she is holding out for a wealthier husband. With instant wit that shows up his intellectual and moral shallowness, Christina replies: 'A more wealthy one, certainly. For who is richer than Christ?'

'Very well then,' said Fredebert, 'will you make a vow that if you do not marry Burthred you will not marry anyone?' Sensing that she has won the round, Christina joyfully agrees. Her fate is only postponed, however. Fredebert, admitting that he is impressed by her

arguments, recommends to Autti that the matter be referred to the bishop, Robert, and Autti takes Christina home and continues to imprison her. When the bishop refuses to force Christina into marriage, Autti bursts out with a bitterness which even the biographer diagnoses as self-pity. 'Today ... you are made mistress over me.'

The horrible dispute raged on, with Autti bribing the bishop to take his side (and succeeding in getting a judgment against his daughter), and with Christina, in a moment of inspiration, trying to persuade Burthred to give her up of his own accord. By now Autti was keeping Christina permanently locked up, and had taken away most of her clothes. Beatrix had resorted to love potions and charms – in vain, of course. Then she turned violent, pulling out Christina's hair and beating her, revealing her to guests in her wounded and dishevelled state.

In this time of acute loneliness and degradation, Christina began to be sustained by visions. Meanwhile Sueno had intervened on Christina's behalf with Fredebert, and as a result Fredebert warned Autti that he might be resisting 'the judgment of God'.

At length Christina ran away (the plan she contrived is described very excitingly) with the connivance of several friends, and eventually took refuge first with a woman recluse, Alfwen, then with a hermit called Roger, hidden by day in great physical discomfort in a tiny compartment in his cell where passers-by could not see her. In this courageous, if desperate, act she had ceased to be the abused Theodora and had become a new woman, Christina. By this time not only Autti and Burthred were on the warpath for Christina, but she had so roused the ire of Bishop Bloet than he too wished to discipline her.

The confinement, fear, and general hardship of life with Roger must have seemed nearly unbearable to a girl in her late teens, and indeed it seriously undermined her health, yet this was Christina's apprenticeship to the life of a hermit, as she found a spiritual mentor in Roger, and began to use the interminable hours of imprisonment in meditation. The editor C. H. Talbot points out that Christina's original attraction had been to the more sociable life of a religious community, and that it was only the peculiar stringency of her circumstances that forced the lonely life of a recluse upon her. The combination of the ambiguity about her married status and the odium she had acquired in some clerical circles would have made her a doubtful proposition for any women's community, even if one of them was prepared to risk the anger of the influential Autti.

But the clouds were slowly clearing. Burthred, who may not have been such a bad young man if not egged on by older and more powerful people, came to see Roger on Easter Day, asking pardon for the way he had treated Christina and offering to release her from her vows. Roger asked her to succeed him at the hermitage after his death, which gave her a kind of status and security. The archbishops of Canterbury and York, approached by various advocates of Christina, took a sympathetic interest in her case and, perhaps most importantly, Robert Bloet died.

Christina continued to have the most extraordinary adventures. At one stage in her life her biographer artlessly describes her suffering sexual longings for a cleric she stayed with when in hiding from Robert Bloet. The cleric roused her desire by appearing naked in front of her and endlessly pleading with her. Frankly attracted to him,

Christina held to her vow of virginity. This is what her biographer regards as 'manful' behaviour!

Gradually the problems of her youth fell away, and Christina became a safe, respected, and admired recluse, with a power of vision, and of seeing below the surface of things, which made her an insightful counsellor. A number of holy women who became known in the later middle ages were famous for knowing things they could not be expected to know – for being able to report conversations at which they had not been present, or to visualize the future with astonishing accuracy. It was as if the life of loneliness and prayer made it possible to tune into life around them at extraordinary depth, or as if, with their dwelling on eternity, past, present, and future were for them inextricably intertwined. Christina was no exception to this. She amazed her sister Matilda by knowing about a private conversation she had had with her husband, and startled various servants or novices who attended her by uncannily knowing their inmost thoughts. Her biographer hints that her parents eventually came to beg her forgiveness and ask her help, though only when punishment by God had made them humble. Unfortunately we have no details of this gratifying role reversal.

A very important friendship came to Christina through a new Abbot of St Albans, the 'noble and powerful' Geoffrey. He had a reputation for arrogance, haughtiness, and undue strictness with his monks, but when the two of them became friends 'he had a deep respect for the maiden, and saw in her something divine and extraordinary'. Her gentle influence softened his difficult and worldly character, and he began to understand more

about the spiritual life and the demands it made upon him. He was intrigued that he could never call upon Christina unexpectedly; she always knew when he or other visitors were on their way to see her.

Geoffrey and Christina developed one of those creative platonic friendships of which there have been many amongst celibates and some others over the centuries. The devotion is plain – they speak of each other as 'beloved'. Christina in her confinement devotedly prayed for Geoffrey, and Geoffrey consulted her about the various problems that bedevil high office. He became more and more influential in the church, until eventually King Stephen sent him to Rome on a mission to Pope Innocent II, one which Christina foresaw as being unlucky, although fortunately it was cancelled. In another dispute with the king, when Stephen arbitrarily imprisoned two bishops, Geoffrey was in some danger since, inevitably, he opposed the king, but this too resolved itself in a way which the story does not make quite clear. Events in the next few years showed what a dangerous tightrope was walked by those, like Geoffrey, who frequented Stephen's court, a lethal web of conspiracy and counter-conspiracy. Christina's dreams, visions, and uncanny perceptions both of psychological states in others and future outcomes, were a very real source of protection for him. A desperate battle was being waged between monarch's power and ecclesiastical power.

Christina's own difficulties were different. Her visions, her sense of being caught up in some huge cosmic conflict of good and evil, cost her a good deal. Like so many of the medieval women mystics she suffered endless mysterious illnesses – whether brought on by poor diet and the

hardships of their life, or by living always on an exhausting edge between God and humanity, eternity and time, it is hard to say. But in one of the most beautiful descriptions of a vision ever written, she describes to her biographer how, lying ill in bed on Christmas Eve, hearing 'the anthem proper to the feast, Christ is born, she understood that she had been invited to the joy of his birth'. She is carried in her mind to St Albans Abbey, and there, in the choir, she sees the living Christ 'looking approvingly at the reverent behaviour of the monks singing'. She is immediately healed.

Unfortunately the end of Christina's life story is missing, and we know nothing of her death. What is perhaps a greater pity is that the life of this gentle and perceptive English saint is so little known in her native country, that her courage and suffering and eventual triumph have not been used as a source of encouragement to Christian women, that her voice of quiet resistance and subversion has been effectively silenced for so many centuries. Still, we have discovered her now, and it is not too late to enjoy and admire her and, in the terms of our own lives, follow her example.

Translator's Note

The fourteenth-century text of Christina's life, now known
as MS Cotton Tiberius E.1., and kept at the British Library,
was originally owned by the monks of St Albans Abbey,
and later passed to the library of the Cotton family. It was
badly burned by a fire at the Cotton library in 1731. The
front and back pages were particularly badly damaged, as
were the edges of a number of the pages. It seemed un-
likely that anyone would ever be able to read it again until
C. H. Talbot, in the 1950s, working in the British
Museum with the aid of an ultraviolet lamp, managed to
make a coherent whole of the Latin text, and then trans-
lated it into English (Oxford University Press, 1959,
Oxford Medieval Texts, 1987). Even this version was
incomplete, partly because of the fire damage, but also
because the final pages of the text had almost certainly
been lost before the fire. Because of this we know nothing
of the last fourteen years of Christina's life nor of her
death. In addition to this, there are a number of places
within the Latin text where Talbot shows us that he is
joining up gaps with a certain amount of guesswork, and
in this respect I have followed his example. This apart, the
text refers to unexplained characters as if the reader
knows who they are, and disappointingly omits to give us
the surely very dramatic story, which it mentions at one
point, of how Christina's parents came to see the error of

their ways. But on the whole the text holds up very well as an effective narrative.

Presumably the fourteenth-century MS was a copy of an earlier text by a St Albans monk, since the author speaks of St Albans Abbey as 'our monastery', or 'this monastery', tells us of his conversations with Christina's mother, and of other local people, and seems fully aware of local events. His graphic and detailed descriptions of Christina's early life and much else in the story have all the marks of having been narrated to him by Christina herself.

Talbot's English version reads a little quaintly today, and in any case his text has only been available in an expensive bilingual academic edition which meant that surprisingly few English people knew of this home-grown saint. For these reasons, I have used his Latin text as the basis of a new English translation, which I hope may be more accessible to a modern reader. Translating the text has (most of the time) felt like a labour of love, and the work gave me, as I went along, an intimate feeling for Christina's fascinating story that was very rewarding. Of course, I could not have attempted the translation without his heroic work on the Latin text.

I shall be delighted if, eight centuries after her death, this new translation helps to make Christina better known.

MONICA FURLONG

THE LIFE OF

CHRISTINA OF MARKYATE

The Life of Christina of Markyate

A virgin of unusual holiness and grace was born into a noble family in the city of Huntingdon. Her father was called Autti, and her mother Beatrix. Her own baptismal name was Theodora, but later, from necessity, she changed it to Christina. Even before her birth she was chosen by God, and seen by others to be chosen. While her mother carried her in her womb, she glanced out one day from their house towards the monastery of the blessed mother of God, which was nearby. And suddenly she saw a snow-white dove leave the monastery and fly softly towards her. It folded its wings and hid itself in the right hand sleeve of her tunic. This happened on the Sabbath, a day used by the devout to remember the Mother of God. It was between the feast of the Assumption and the day of the Nativity of Our Lady. What's more, as Christina's mother told me herself, the dove behaved as if it were tame, and stayed quietly with her for seven days. It liked to be stroked by her, nestling with pleasure in her bosom and on her lap.

This sign made it clear that the child she bore would be filled with the Holy Spirit, the same Spirit who appeared above the head of the Lord Jesus in the form of a dove and was described by the prophet Isaiah as being endowed with sevenfold grace. It showed also that she would follow the example, and enjoy the protection, of the Blessed

Mary, ever a virgin, and she herself would be holy both in body and mind. She would detach herself from this world, and rest in the contemplation of the heavenly mysteries, rather like the dove itself. Brooding on these things, Christina's mother said that she thought she would have a child who would be very pleasing to God. And so she carried her child with gladness until the day it was expected.

When the day came, Beatrix went to church, heard Matins and the other hours, and attended Mass. And commending herself at each service to God, and to his Virgin Mother, and to the holy Leonard, whose feast was celebrated that day, she returned home at the end of the office. Between six o'clock and nine o'clock of that day, that is, on 6 November, she gave birth to a daughter, sustained during her labour by the hope she felt about her child. The child grew and was weaned, and she grew in goodness as fast as she grew in body. So it came about that while she was still at the stage when she did not fully understand the difference between right and wrong, she beat her young body with rods whenever she thought she might have done something that was wrong. But she was still unable to understand why she should love righteousness and hate wickedness.

Meanwhile, having heard that Christ was good, beautiful and everywhere present, she would talk to him in bed at night, as if to a person she could see. This she did in a high, clear voice, which everyone in the house could hear, since she imagined that when she was talking to God she could not be heard by other people. She changed this habit when they made fun of her.

In those days there was an elderly canon of Huntingdon called Sueno, famous for his good life and

sound theology. He met Christina by accident when she was quite small, and later on often sought opportunities to meet her and talk to her, which happened quite often. Both gained from these conversations. Then, as the girl decided to serve God by remaining a virgin, the man of God did his best to affirm her in her resolution. Sometimes he explained the difficulty of virginity, sometimes he extolled its glory, saying that it was difficult to preserve, yet it was glorious to do so. Once, when he talked of all this, someone said this: that he himself burned with lust, and that if God, with his greater power, did not prevent him, he would shamelessly lie with a sick and deformed leper. Christina heard this with great disgust and interrupted indignantly, saying, 'If you have good things to speak about, speak and I will listen. If not I will go away at once.' Which remark so struck her listener with the virtue of holiness that his life after that, compared to his former life, was like lead compared to iron. And as cement binds the stones in the wall, her sharp comment established him firmly in divine love. Meanwhile she made so much progress through the teaching and exhortation of Sueno that the things of this world seemed to her like a shadow.

Then, by an act of divine providence, Autti and Beatrix brought their dear daughter Christina with them to our monastery of the blessed martyr St Alban, where his holy bones are venerated. They came to ask his protection for themselves and for their child. When therefore the girl had studied the place, and regarded the sober bearing of the monks who lived there, she said how happy they were, and said how much she would like to live as they did. At last, as her parents were leaving, having completed their

act of pilgrimage, she drew a cross with her fingernail upon the door as a secret sign that she had placed her affection there. It is worth noting that it was the feast day of St Leonard, the same day on which she had first seen the light of this world. That night they travelled as far as the village of Shillington and spent the night there. The rest of the party gave themselves up to frivolity and amusement. The virgin of Christ spent her time alone in holy meditation. She pictured herself lying on her death-bed, as if the future were already happening, and it occurred to her that once life had left the body no one knew where the spirit went. However, one thing was sure – that if she lived a good life her spirit would enjoy bliss, and if she lived badly, she would suffer the torments of hell. After this she lost all interest in worldly pomp, and turned to God with her whole heart, saying, 'Lord, all my desire is before you, and my groaning is not hid from you' (Ps. 38:9). 'Whom have I in heaven but you? And there is none upon earth that I desire beside you. My flesh and my heart fail; but God is the strength of my heart, and my portion for ever. For, lo, those who are far from you shall perish; you have destroyed all those who go a-whoring from you. But is is good for me to draw near to God: I have put my trust in the Lord God, that I may declare all your works' (Ps. 73:25-28).

The next day she went to church where the priest was celebrating Mass. After the Gospel Christina approached the altar and offered a penny, saying in her heart, 'O Lord God, merciful and omnipotent, receive my offering through the hands of your priest! For as I offer this penny, so I give myself to you. Grant to me the beauty and integrity of virginity, through which you may repeat in me

the image of your son, who lives and reigns with you in the unity of God the Holy Spirit for ever and ever. Amen.'

After she had returned to Huntingdon she told Sueno what she had vowed, and he, who was regarded in those parts as a light of God, confirmed the virgin's vow before God. Christina stayed tranquilly at home, happy that she could grow from day to day in holy virtues, and in the love of holy things. But the envy of the devil was not able to bear this and, longing to upset her peace of mind, he took the following steps.

Ralph, the Bishop of Durham, was justice for the whole of England, taking second place in the State after the king. Before he became a bishop he had consorted with Christina's maternal aunt, Alveva, and she had borne children by him. Later he gave her in marriage to a burgher of Huntingdon, but for her sake he continued to take an interest in the rest of her family. On his way from Northumbria to London, and on the way back, he always stayed at her house. One time when he was there Autti, his friend, had done as he usually did, and brought his children to meet him. The bishop stared hard at pretty little Christina, and immediately Satan put it into his heart to desire her. Intently seeking some ingenious method to get her into his power, he had the unsuspecting child brought into his sleeping chamber, which was hung with beautiful tapestries, the only others within earshot being members of his entourage. Her father and mother, and the others with whom she had come, were in the hall drinking themselves senseless. When it grew dark, the bishop gave a secret signal to his servants and they went away, leaving their lord and Christina, the wolf and the lamb, together. How dreadful!

The shameless bishop grasped Christina by one of the sleeves of her tunic, thrusting the mouth which consumed the sacred elements upon hers, to tempt her to commit a sin. What could a child do in such a desperate situation? Call her parents? They were already sound asleep. It was impossible for her to consent to his desires, but it was not possible to resist him openly. If she did so, she knew she would be overcome by force.

Listen, therefore, to how clever she was. She glanced at the door, and noticed that though it was closed, it was not barred. So she said, 'Let me go and bar the door, for even if we are to break the law of God, we should at least be careful that no one catches us in the act.' He made her swear that she would not deceive him, but would bar the door as she had said. She promised. As soon as she was free, she hurried out of the room, barring the door firmly from the other side, and hurried home. This was the beginning of all the dreadful troubles which later pursued her.

This perverted man, realizing that he had been made a fool of by the young girl, was beside himself with rage and resentment, and plotted revenge. The only way in which he could conceivably get his own back was by deflowering Christina, either alone or with someone else to help him, since she did not hesitate to repulse even a bishop.

Meanwhile he hid his intentions and set off for London. When he returned he came to Huntingdon, bearing silk dresses and other precious ornaments which he offered to the girl. But she despised them and treated them as mud. Although he had first been possessed by lust, and then by jealousy, he could see that he would get nowhere

with her, so he spoke to a young nobleman called Burthred, urging him to propose marriage to Christina, and promising to further his suit in every way he could. The young man followed the bishop's advice, and the bishop himself followed up the matter with such aggressive persistence that he extracted a promise from her parents. Against her will Christina found that it had been agreed that she should be betrothed to Burthred. After arranging this, the prelate, delighted at his victory, went to Durham, leaving the girl desperately unhappy in her parents' home. After this the young man visited her father and mother in order to arrange the betrothal with the girl they had promised would marry him. When they spoke to the girl about marriage, she would not listen. When they asked her why, she replied that she would rather remain chaste, for she had made a vow to do so. Hearing this they sneered at her precipitate promise. But she stood firm. They tried repeatedly to convince her of her silliness, and despite everything she said, urged her to advance the happy wedding day. She refused. They offered her presents and made large promises, but she would have none of it. They flattered her, they threatened her, but she would not give way. At last they persuaded one of her best friends and most regular companions, Helisen, to influence her by continually admiring her, hoping it would give her an inflated sense of her own value, and encourage her in the desire to be mistress of her own home. (We knew this same Helisen later when she took the veil, in order, we believe, to expiate her wrongdoing towards Christina.) She repeatedly tried to break down her friend's resistance, believing she would eventually succeed, as in the proverb 'Constant dripping wears away a stone.' All the same,

although she devoted a year to this enterprise, she was unable to squeeze a single word of agreement from her.

Later, however, on a day when they were all together at the church, the group made a concerted and unexpected attack on her. What happened? I do not know. I only know that with so many bringing pressure to bear on all sides, she gave way and agreed, and on that same day Burthred was betrothed to her.

After the betrothal the girl returned again to her parents' home, while her husband, although he had houses in other parts of the country, had a new and bigger house built near to his father-in-law. Although Christina was now promised, her attitude had not changed, and she insisted that she would not lie carnally with any man. The more her parents realized the extent of her obduracy, the harder they tried to change her mind – by flattery, by reproofs, sometimes by presents and splendid promises, as well as by playing on her fears by threats. And although her near relatives and others worked on her separately and together, her father Autti worked still harder, and was himself surpassed by the girl's mother, as will become clear later in the story.

After they had tried a lot of different ways of tempting Christina, they finally decided on the following ruse. Keeping her under strict surveillance, they prevented any religious and God-fearing man from being able to talk to her. But they did admit anyone and everyone to the house who was given to frivolity, idle witticism and worldly tastes, and those whose evil communications corrupt good manners. They increased the pressure by stopping her going to the monastery of the Blessed Mother of God, ever virgin, because they could see that whenever she went

there she came back rooted and strengthened in her resolution. This was very hard for her and, to those who forbade her to go, she said with passionate feeling: 'Even though you stop me from visiting the monastery of my beloved mistress, you cannot tear the sweet memory of it from my heart.' They prevented her going to the chapel that was most dear to her, not allowing her to visit it, but they forced her to go with them to banquets, where many delicious foods were served accompanied by wines, and where the delightful music of the singers was accompanied by the notes of the zither and the harp, hoping that by listening to them her determination might be weakened and she might gradually come to long for the pleasures of the world. Their stratagems, however, were always outwitted by her shrewdness and circumspection.

See what she finally did, how she conducted herself at what is known as the Gild Fair, which is one of the merchants' biggest and most famous festivals. On one occasion, when many nobles came together at the Fair, Autti and Beatrix, as the senior in rank, presided. They decided that Christina, as their first-born child and most worthy daughter, should act as cup-bearer to the distinguished gathering. Wherefore they instructed her to get up from her place and lay aside her mantle, so that, with her gown fastened to her sides with bands and her sleeves rolled up to reveal her arms, she might gracefully offer drinks to the nobility. Their hope was that the comments made to her by the company, and the custom of taking little sips of wine, would break down her resolution and urge her body to the act of corruption. Doing as she was instructed, she shielded herself against both forms of attack. Against the appeal of human flattery she fixed in her mind the

thought of the Mother of God, and she was helped in this by the hall where the occasion took place, since because of its size it had several entrances. One of these, which Christina frequently passed, looked out on the monastery of the holy Mother of God, and each time she saw it she recited the Hail Mary. Against the possibility of drunkenness, she preferred to suffer acute thirst. It is not surprising she felt dry, since although she had been pouring wine all day for others to slake their thirst, she had had nothing to drink. Late in the evening, faint with heat and thirst, she drank a little water and so satisfied her need.

Unsuccessful in their plan, her parents tried another tack. At night they let her future husband secretly into her room thinking that, if he found her sound asleep, he might take her by surprise and overcome her by force. But thanks to the providence to which she had committed herself, he found her awake and dressed. She received the young man as if he were her brother, and sitting beside him on her bed she lectured him on leading a chaste life, mentioning the saints as examples. She told him the story of St Cecilia and her husband Valerian, describing how when they died an angel bestowed on them crowns of chastity. In addition to this, they, and many more later, had followed the way of martyrdom, and thus were crowned twice by the Lord, achieving honour in both heaven and earth. 'We also might follow their example and meet with them in glory. Because if we suffer as they did, we shall also reign with them. Do not be hurt that I have refused your advances. So that your friends will not laugh at you for being rejected by me, I will go home with you. We might live there for a while, seemingly as husband and wife, but chaste in the sight of God. But first let us

shake hands in a compact that neither will touch the other unchastely, nor look upon the other except with a glance as pure and candid as that of an angel. Let us promise that in three or four years' time we shall take the habit of religion and offer ourselves to some monastery which providence will propose.'

Most of the night was passed with such talk as this, and then the young man left. When those who had smuggled him into the room heard what had happened, they called him a spineless coward. And with many reproaches they goaded him to try again, and forced him into her bedroom another night, having warned him not to be distracted by her wiles, or her simplistic sermons, to the point where he lost his manliness. He was exhorted to achieve his goal either by charm or force. And if neither of these worked, he was to remember that they were at hand to help. He just had to act like a man.

When Christina realized what was going on she leaped out of bed, and clinging for dear life to a peg fixed to the wall, she hung trembling, concealed by the tapestry. But Burthred approached her bed, but not finding what he had expected, he called to those waiting outside. They burst into the room, and with torches in their hands ran about searching for her, the more determined since they knew she had been in the room when he had entered, and could not have escaped them unseen. You can imagine how she felt. She shook with fear as she heard their frenzied search. She almost fainted with terror as she pictured herself dragged out into the room, overcome by their all staring at her, threatening her, a young girl abandoned to the power of her seducer. One of them actually touched and held her foot as she hung there in hiding, but since the

tapestry between them deadened his sense of touch, he let go, not knowing what he held. Then the servant of Christ, feeling braver, prayed to God: 'Let them be turned backwards, that desire my hurt.' And just then they left, furious at being made fools of, and after that she knew she was safe.

All the same, Burthred came into her room a third time, angry and agitated. But as he came in through one door she fled through another. Before her was a high fence which, because of its height and the spikes on top of it, seemed impossible to climb. A few steps behind her was Burthred, who she thought would catch her at any moment. With surprising ease she leaped over the fence and, glancing back from the safety of the other side, she saw that Burthred was unable to follow her. Then she said, 'In escaping him, I escaped from the same demon I saw last night.' In her sleep she had seen a terrifying demon with blackened teeth who was trying to seize her, unsuccessfully, because she had leaped, at one bound, over a high fence.

As her parents were laying these and other traps for her, they kept trying to fix the date for the marriage with Burthred. They imagined some situation would arise in which they could take advantage of her. For which of us could hope to escape so many pitfalls? Yet with Christ watching over the vow that his bride had made, it was out of the question for this wedding to take place. In fact, when the day they had arranged approached, and all the essential preparations for the wedding had been completed, first of all the things prepared were destroyed in an unexplained fire, and then the bride-to-be developed a fever. In order to cure the fever, they

plunged the sick girl into cold water before almost roasting her.

Meanwhile the rumour of Christina's marriage reached the ears of Master Sueno, the canon mentioned earlier. Christina, of course, was kept in close custody, which did not allow him to visit her, nor to receive any message sent by her. He thought she had changed her mind about her vow of virginity and accused her of the inconstancy of women, saying, 'Now I shall never trust another, since the one I believed in so much has deceived me.' It eventually reached Christina's ears that her one friend had turned against her, and that he now bitterly regretted having ever been her friend and counsellor. When she heard this, she felt terrible grief and sat rigid and fixed as if turned into stone. Then, heaving deep sighs, she burst into a flood of tears, and sobbing and lamenting, she cried out that she was now a lost orphan. For, sneered at and tormented as she now was by parents and friends, Sueno had been her only comfort. His kindness and sympathy had been to her such a source of strength that what she had endured elsewhere had not mattered as much as it might. But now, while she remained staunch, he had abandoned her. Unbelievably, she was left alone surrounded by her enemies. He had turned his back on her.

But had Christ deserted the one who trusted him? Of course not. He looked with pity on the lowliness of his handmaiden. Quickly she turned to him, saying, 'Lord, how are they increased that trouble me. Many are they that rise up against me. I have looked for some to take pity, but there was none, and for comforters, but I found none. Unto you, O Lord, do I lift up my soul, to you who have said to your followers: Blessed are you when men

shall hate you: and when they shall separate you from their company and shall reproach you, and cast out your name as evil for the Son of Man's sake. Rejoice in that day and leap for joy: for behold your reward is great in heaven. I believed that Sueno would be my supporter in the day of trial and I have been forsaken. But truly loving and following you, bearing the persecutions of men for you, in you is my trust. For the more a person is despised by men, the more precious she is in your sight.'

Saying this, she felt strengthened by the Holy Spirit, and found that all of a sudden she felt complete confidence. And there is no doubt that, at this point, she, who had been baptized Theodora, deserved the new symbolic name by which she came to be called, that is to say, Christina. Just as Christ was rejected by the Jews and later denied by Peter, the prince of the Apostles, who had loved him the most, and was made obedient to his father even unto death, so this girl was first afflicted by her parents, then abandoned by her only friend, Sueno. As a follower of Christ, she sought only to do his will.

In this situation, while her parents were abusing the servant of Christ and growing angrier and angrier with her, the truth of what was going on was conveyed to Sueno. Thinking of the courageous determination of the consecrated girl, and reflecting on his own lack of loyalty, he grieved wretchedly, and striking his breast with his fists punished himself for his own error. Seeking anxiously to talk to the friend whom he had wounded, and finding this was impossible because of the strictness of those who watched her, he heard eventually that she was to accompany her parents to the church of the blessed Mother of God in order to attend the funeral of a noble kinsman

who had died. And I believe that this was arranged by
Sueno. When he saw his opportunity he sent secretly to
her several times begging her, for the love of Christ, not to
refuse the company of a miserable old man, though she
had every excuse to do so because of his lack of trust.
Raising his hand to his eyes, he wept so bitterly that the
tears poured through his fingers. He called God as his wit-
ness that he regretted this failure more than any other in
his life, at which she pardoned him for his wrongdoing,
and they renewed their old friendship. This made both of
them very happy. He remained in his monastery, and the
girl went back home with her parents.

Her father took her back to the monastery another
time and standing her before Fredebert, the reverend
prior, and the other canons of the chapter, addressed
them in these self-pitying words: ' I know, fathers, and I
admit to my daughter, that I and her mother have forced
her against her will into this marriage, and that against
her better judgment she has been betrothed. But no mat-
ter how the situation arose, if she defies my authority and
refuses to accept it, we shall be the laughing stock of
everyone we know, and the object of jokes and scorn of
the entire neighbourhood. So I beg you, persuade her to
see it from our point of view. Why can she not have a reli-
gious marriage and save my honour? Why must she be so
different from other girls? Why should she want to see me
publicly disgraced? If she takes up a life of poverty it will
make the world of the nobility look ridiculous. If now she
will do as we ask, she can have whatever she asks from us.'

When Autti had finished Fredebert asked him to leave
them, and before the canons he spoke to the girl like this:

'We are really surprised, Theodora, at your obstinate

attitude, or perhaps we should say your folly. You have been properly betrothed according to church custom. It is well known that the sacrament of marriage, which has been created by divine law, cannot be dissolved, because whom God has joined together, no one should rend asunder. For this reason a man will leave his father and mother and cleave to his wife. And they two shall be one flesh. The Apostle says: Let the husband cherish his wife, and in the same way let the wife cherish the husband. Because the woman does not have power over her own body, but her husband does. Similarly the man does not have power over his own body but the woman does. I lay down this precept, yet not I, but the Lord, that the wife must not leave her husband, and the husband may not send away his wife. We know the rule given to children: Honour your father and mother and show them respect. These two commandments, about obeying your parents and being faithful in marriage, are very important, and frequently commended in the Old and New Testaments. Yet the strength of the marriage bond is so much more important than parental authority that if they instructed you to dissolve the marriage you should not listen to them. However, they are ordering you to do something which we know from the highest authority is more important than obedience itself, and you do not listen to them. You are at fault twice over. Perhaps you think that only virgins can be saved? Not true, since while many virgins may be damned, many mothers of families are saved, as we know very well. This being the case, nothing should stop you from taking our advice and teaching, and submitting yourself to the lawful embraces of the man upon whom you have been legally bestowed in marriage.'

To this speech Christina replied: 'I know nothing of the scriptures you have quoted, Father Prior. But from a general sense of what they say, I would like to respond to what you have said. As you have heard, my father and mother agree that this sacrament, as you describe it, was forced upon me against my will. I have never thought of myself as a wife, nor had any wish to be one. In early childhood I made the decision to live a chaste life, and I vowed to Christ that I would remain a virgin. This happened in front of witnesses, but even if this had not been so God would be my ever-present witness. I revealed my dedication by my actions as far as I was allowed. Because my parents forced me to marry against my will, and to break the vow to Christ which they know I made as a child, I ask you, who know more than other men about the content of the scriptures, to judge whether this is right or wrong. If I do all that I can to fulfil the vow I made to Christ, this is not to disobey my parents nor to go against the precept of God. What I do I do at the invitation of him whose voice, as you say, speaks through the Gospel, saying, "Everyone who leaves house or brethren or sisters or father or mother or wife or children or possessions for my name's sake shall receive a return of a hundredfold and inherit eternal life." It isn't that I think only virgins can be saved. But I believe as you do, and it is true, that if many virgins perish, so do rather more married women. And if many mothers of families are saved, which you also believe, and it is true, undoubtedly virgins are saved more easily.'

Fredebert, startled at the common sense and intelligence of Christina, asked her, saying: 'How can you convince me that you are doing this for the love of Christ?

Perhaps you think that by refusing marriage to Burthred, you can manage to find a wealthier husband?'

'Certainly a wealthier one,' she replied. 'For who is richer than Christ?'

Fredebert said, 'I am not joking, girl, I am talking seriously with you. If you wish us to believe you, you must take an oath here that, were you betrothed again as you were to Burthred, even if it were the king's son, you would not marry him.'

Then the girl looked up to heaven and, full of joy, replied, 'I will do more than take an oath, I will prove what I say by carrying red-hot iron in my bare hands. As I keep saying, I must fulfil my promise which I made through the action of his grace to the only Son of the great King, and with the help of the same grace, I intend to fulfil it. And I trust in God that the time is not far removed when it will become clear to everyone that I look to no other husband but Christ.'

Fredebert then summoned Autti and said to him: 'We have done our best to persuade your daughter to your will, but to no avail. Soon, however, our bishop, Robert, will be coming to his house at Buckden, which is near here. It seems reasonable that this case should be laid before him. Let the matter be put into his hands, and let Christina accept his verdict, if no other. What is the point of distressing yourself so much, and suffering to no useful end? We do believe that the determination of this young woman is built on genuine virtue.'

Autti answered, 'I accept what you say. Please approach the bishop in the matter.' Fredebert agreed, and Autti took his daughter home, and placed her under the usual restraint.

Meanwhile he learned that the bishop had come to Buckden. Fredebert immediately went to see him, pushed into it by Autti. Along with him went some of the most distinguished local citizens, who thought that, as the marriage had already been performed, the bishop would immediately tell the betrothed young woman to submit to the authority of her husband. So they immediately put before him in detail everything they knew about the business, what Christina had done, what others had done to her, starting with her childhood and bringing it up to the present day. Eventually they made the suggestion that since neither suffering nor bribery could influence her, she should be forced to accept the marriage by the authority of the bishop. After studying all the evidence carefully, the bishop said: 'I declare, and I swear before God and his holy mother, that no bishop under heaven could force her into marriage if, according to her vow, she chooses to keep herself for God as his faithful servant and to serve no man besides.'

Hearing this answer, which was not what they had hoped for, they returned in confusion and repeated the bishop's reply to Autti. When he heard it, he sank into despair. Full of self-pity, and deserving of pity, he said to Christina: 'Today, peace is declared, you have been made mistress over me. The bishop has sung your praises and set you free. Come and go as I do, and go your own sweet way, but don't expect any kindness or help from me!'

After this, he grew more and more miserable. Observing this, Robert, the dean, and others, felt sorry for the wretched man. Discussing how they could relieve his suffering, they suggested a way in which he could force his daughter to marry, saying: 'Do you know why the

bishop gave that ruling the other day contrary to what was rather naïvely asked of him? If you had offered him money, your cause would certainly have triumphed. You must know of his greed and the corruptness of his nature. Either of these alone would be enough; even better when they occur together! His greed will persuade him to pervert justice, and his incontinence to resent other people's chastity. If he thinks he will get money out of a friend, then he is all for him. So make sure that he is on your side, and there should be no further problem. And in order to get your own way, don't hesitate to use us to intercede for you.' After this, Autti recovered, and shared all his troubles with them. How shameless men can be in despising God, and rebelling against his power! But there were two reasons involved, which it may be interesting to mention here. For once they are recognized, it becomes obvious that parents can act in this way against their own flesh and blood.

One reason was the family's habit of pursuing to the bitter end anything it had once started, whether good or bad, except where it became clear that success was out of the question. And while it is virtuous to persist in good, it is wicked to persist in evil. Another reason was that Christina was a young woman so remarkable for her honour, her integrity, and her grace that she was widely loved and admired. In addition, she had so much common sense, intelligence, and practical ability that if she had chosen to occupy herself with worldly matters she could have done well for herself and her family, as well as other relatives. In addition, of course, her parents hoped she would have children who would resemble her in character. These considerations alone made them deplore the

thought of her living a celibate life. For if she chose to remain the virgin of Christ they would lose her and all they might have gained through her. They cared for nothing but the pleasures of this world, believing that anyone whose life lacked them and sought only spiritual good, would end in disaster.

We were to see it turn out quite differently! For Christina did abandon the world, and devoted herself entirely to being the spouse of Christ the Lord, as she had vowed she would. While her parents, on the other hand, were eventually abandoned by the world, and had to turn to her whom they had driven away, finding with her salvation for their souls and a refuge for their bodies. In this way Christina confounded her parents.

Let us return to the story. While Autti was secretly conferring with his friends about an appeal to the bishop, Christina was brooding about what their secret meetings could mean, and in her anxiety she worried about everything, as women will. Meanwhile, as she tried to think of a way to subvert any possible plots, it occurred to her to try to act before they could. She sent two men of considerable standing, Sueno the canon, and her father's chaplain, to Burthred to ask him to release her from her betrothal. Among other things she invoked the bishop's pronouncement and begged him not to try to fight her on the issue, since there was a ruling by such an important authority. When these two added their own persuasion to Christina's plea, Burthred, encouraged by what the bishop had said, answered: 'If, as you say, speaking as surrogates of Christ, my wife is acting, not out of contempt for me because she wants to marry another, but because of a vow to Christ, then I am ready to release her in the

sight of God and yourselves, and I will make financial provision for her, so that if she wishes to enter a monastery she will be admitted by the community without difficulty.'

They said to him, 'These are wise and Christian sentiments. And to remove any doubt about your wife's position, we are sureties that her virginity shall remain intact. For the time being there is no need to make any provision for her, but if you will release Christina from her betrothal, do so now to us as if she were not absent but present.' And he did so.

When Autti and Beatrix heard about this, they felt tremendous anger, and turned furiously both on those who had pleaded for Christina, and upon Christina herself, insisting that such an arrangement could not and must not be valid, because they had not consented. And they forced Burthred to change his mind, but not without enormous effort. After this they sent him along, tormented by their alternate upbraiding and flattery, with the dean and others, whom we have mentioned before, to see the bishop. And by not saying very much, but offering him large bribes, they bent him to their will. Christina did not know about this.

Later, at the bishop's command, Burthred and Christina appeared before him. While Burthred was outlining his case against her, the bishop remarked: 'Take counsel, Christina.' Not realizing that he had been bribed, and trusting his earlier judgment, she replied: 'Whose counsel is better than God's and yours, most holy father?'

'That's right,' said the bishop, and handed her back to Burthred. Then she was returned to her father's house.

Burthred sat beside her, mocking her and boasting that he had bested her before two bishops, Durham and Lincoln, and that he did not intend to bring her before a third. Christina prayed and said, 'I wish that this last judgment of yours was as true as the previous one was false. For how can you claim to have succeeded, since, with God's help, I never have been yours and I never will be, even if I should be torn limb from limb! Tell me, Burthred, if you hope God will have mercy on you, if another man should come and take me away from you and marry me, what would you do?'

He replied: 'I would never permit it, as long as I lived. I would kill such a man with my own hands, if that was the only way of keeping you.'

To this she retorted: 'So what about you stealing the bride of Christ? Maybe in his anger he will kill you!' And when she had said this, she stood up to go, but when she got up he grabbed her mantle to hold her back. As she moved away, she released it at the neck, and leaving it, as Joseph had once done, in the hands of her captor, she quickly escaped into her own room.

Then her father was beside himself with anger, and stripped her of all her clothes except her shift, and taking from her the keys which were in her keeping he made up his mind to drive her naked out of the house that very night. Autti was a very rich man, of course, and had always felt that he could entrust Christina with his silver and gold, and any other treasures he happened to possess. But now, enraged beyond bearing, and holding her keys in his hand, he said to the girl, stripped of most of her clothes, though happily clothed with the modesty of virtue, 'Go on, get out! If Christ is what you want, then

have him, stripped of everything else.' And he would have sent her out into the night there and then, but that a guest staying in the house pleaded for her. Christina herself would have preferred to be sent away, naked and at night, just to get her freedom to serve Christ.

But when morning came, she left the house unlet and unhindered. When Autti learned of it, however, he chased after her and brought her back against her will. From then on, her mother Beatrix, with God's permission (as a parent), but driven by the devil, vented her fury on her own child, not neglecting any sort of wicked trick which might, she thought, crush the girl's integrity. She had been unkind to her before this, of course, but now she abused her with extreme cruelty, sometimes openly, sometimes privately. Finally she swore that she would not care who deflowered her daughter provided that someone did. She began to squander a lot of money on wise old women so that with their love potions and spells they might drive her crazy with sexual desire. But their strongest charms had no effect. A Jewess was hired to bend Christina's will with spells more powerful than the others, and she visited Autti's house. As she saw Christina walking past, she said to her mother Beatrix: 'We are wasting our time here. I can see two spirits, two persons, so to speak, dressed in white, who accompany her always and protect her from every sort of assault. Better to give up now rather than to keep trying in vain.' But Beatrix stubbornly indulged her malice, and as she could not break her daughter's will, she took a grim satisfaction in the misery she inflicted on her. Once, on a whim, she took her out of a banquet, and, in another room, pulled out her hair and beat her until she was black and blue. Then she brought the wounded girl

54

back into the gathering for the revellers to stare at, with weals on her back from the blows. The scars remained as long as she lived.

Wishing to comfort his suffering bride, Christ consoled her through his holy mother in the following way. One night in a dream she was brought with other women into a beautiful church. At the altar stood a man in priestly garments, preparing to celebrate Mass. Looking round, he beckoned Christina to come to him. And when she approached trembling, he held out to her a branch of the most beautiful leaves and flowers, saying, 'Receive this, dear one, and offer it to the lady.' Then he indicated a lady, regal as an empress, sitting on a dais not far from the altar. Curtsying, Christina held out the branch she had been given. And the lady, taking the branch from Christina's hand, gave back a twig of it and said, 'Look after it for me.' Then she went on: 'How are you?'

She said, 'Very bad, my lady. On all sides I am mocked and abused. I feel that no one suffers as I do. I cannot stop sobbing and crying from morning till night.'

'Don't be afraid,' she said. 'Go in peace, since I will free you from your persecutors, and bring you into the light of day.' So she went away, full of joy, holding the little branch of blossoms in her right hand. And descending some steps she saw Burthred, wrapped in a black cloak, stretched out with his face pressed to the ground. And when he saw her passing he put out a hand to grasp and hold her. But she pulled her white and flowing garments closely around her and passed him untouched. And as she moved away his eyes followed her, and he groaned miserably, and banged his head repeatedly on the pavement from rage.

Then she looked before her and saw an upper room, high-ceilinged and quiet, which could be reached by a flight of steps, steep and difficult for anyone to ascend. Christina longed to climb them, but as she hesitated because of their steepness, the queen whom she had just seen helped her, and she reached the upper chamber. And as she sat there, enjoying this delightful place, the queen came and laid her head in her lap as if she wished to sleep, with her face turned away. Seeing her face turned away from her distressed Christina and, not daring to say anything, she mused: 'Oh, if only I might look upon your face!'

Immediately the empress turned towards her and said to her with enchanting kindliness, 'You may look briefly at me now. Later, when I shall bring both you and Judith into my chamber, you can look as long as you wish.' She awoke from the vision and found her pillow wet with tears, which made her feel that just as the tears she dreamed she had wept were real, so were the other things that she dreamed. From then she was completely changed, and the great joy which filled her at the thought of freedom could be seen by everyone in her happy face.

In the meantime she managed to find a chance to talk to Sueno, her confidant, longing to share with him this unexpected joy. She described the vision in detail. Sueno then repeated it to the prior Fredebert. Fredebert sent for Autti and said to him, 'Listen to me, and do not shrink from the judgment of God. Do not make Christina suffer any more, but give her her due as the bride of Christ. If what I have heard is true, those who seek to harm her or to struggle against her are wasting their time.' And he gave him the reason.

When Autti heard this, he was angrier than ever, as were his advisers. Once having had their wrath aroused, they were quite simply unable, for any reason at all, to let their emotions cool, as I explained before. Noting this, the Virgin of Virgins appeared again to Christina in the following way. The handmaid of Christ observed herself standing quietly alone when, unexpectedly, the queen of heaven was before her. And as she was admiring the loveliness of her features, and gazing with love, she said to Christina: 'Why are you looking at me so intently? Is it because I am the greatest among women? Do you wish to know how great? As I stand here I can easily touch the highest point of heaven. Know that I have chosen you from your father's house, and not only you but your companion also.' And she named a particular man who, after his conversion, became a most devoted monk in our monastery. I must not give his name because I was told not to do so.

As the obduracy of Autti's party could not be softened, Sueno prayed to Christ day and night for a happy outcome for the suffering girl. And eventually his prayers and his tears were heard. One day, while he was standing at the altar saying Mass, he heard a voice saying: 'Fear not, Sueno. I will release the woman for whom you have prayed. You will see her with your own eyes, and speak to her with your own lips as soon as she is free, and your heart will rejoice.' Then the voice ceased. Meanwhile, however, Christina was spared nothing – every day increasingly harsh measures were taken against her to reduce her liberty. But the time was not far away when God's promise would be fulfilled, and in all this her wisdom and courage is demonstrated.

Not far away there lived a man called Edwin, who lived as a solitary in the religious life. Christina longed to talk to him in order to ask his advice. The only way she could manage this was to give bribes to her guards, so she gave them money, and somewhat timidly sent a message to Edwin, having asked his consent first. He came secretly to see her. Seizing their chance, they spoke briefly together while they could. She asked his advice about escaping, and he promised to help her. When they'd finished talking, he left her, and his visit was skilfully hushed up. Then, as he tried out several possible hiding places in his mind, he kept returning to the thought of a relative of his, Roger. Roger was now an old man, wise in the spirit, a deacon in holy orders, a professed monk, and generally considered as an equal to the Christian fathers because of the holiness of his life. He was a monk of ours, but lived as a hermit, though he remained under obedience to his abbot. His hermitage was situated on the right hand side of the road as you leave our monastery to go to Dunstable. The hermitage had come to Roger by God's gift, and was acquired with the help of angels. For, when returning from Jerusalem, he was met at Windsor by three angels wearing white mantles and stoles, each holding in his hand a cross above which floated the same number of lighted tapers. Walking visibly with him, they accompanied him to the site of the hermitage and settled him there. Here he was to undergo much suffering, but on the other hand he also experienced divine consolation, which so satisfied him that he counted suffering as nothing at all, standing, as he did, steadfast and faithful in the commandments of the Lord. No one suffered more from the wickedness of the Evil One, or endured more bitter temp-

tation, or resisted so many traps. Protected by the armour of the cross of Christ he overcame the one and avoided the other. Who could have been harder on himself? He permitted himself no sensual pleasure. His purpose was solely to advance in the service of God. His compassion for the afflicted and their miseries was so great that he would not have minded their sufferings more if he had had to endure them himself. We have written these few words about the old man by way of an introduction, because we think they are very relevant to our story. All else about him is silence, both because it is hard to describe, and because there is no need to set it out here. I am speaking of his spirit of prophecy and contemplation in which he was thought to be remarkable.

This old man, then, received an immediate visit from his cousin Edwin, whom we mentioned earlier, asking him to take the virgin of Christ under his wing, as he himself dared not do because of her parents. This was because her family was so ancient and influential in England, and the whole district around Huntingdon for many miles was full of her relatives. When the holy man heard that she was from Huntingdon, he asked after her in great detail, wanting to learn about her character and her way of life. For a long time he had been waiting to see something or someone he knew would come to him from Huntingdon, but he did not know what or who it would be. Edwin set out the whole story very clearly, and the old man listened carefully. But when Edwin told him that she had been married, Roger flashed a furious glance upon him, saying angrily: 'Have you come here to instruct me on how to dissolve marriages? Get out of here at once, and think yourself lucky to get out sound in limb. You deserve a

good thrashing!' And he pushed him violently out of his cell. Since the good man would not even discuss a separation of married partners, Edwin, not knowing what to do, began to give up and perhaps wished he had not undertaken such a task. And he would have gone back home without doing anything else, had it not occurred to him to take the matter to the Archbishop of Canterbury for advice. At the time the Archbishop was Ralph, a man very knowledgeable about both divine and civil law, as a man in his shoes should be. He was respected by everyone for his piety.

So Edwin set off for Canterbury, determined to do whatever the venerable old man decided. He arrived there, asked for an audience with the archbishop, and was received by him. The others in the room went away and the hermit was left alone with the archbishop. Edwin slowly explained to him the life Christina had led, told him how she had vowed her virginity to Christ as a child, and what her parents had done because of it. Nor did he gloss over her marriage, but explained the compulsion and deceit that had led her to it. Finally he told of her plan to escape and sought advice on whether this was permissible or not. When the archbishop asked him about the girl's purity, the hermit answered that she was uncorrupted in body and mind. Then, like the faithful servant of God that he was, the archbishop was shocked at the suffering of Christina, but thanked God for her endurance as a brave soldier of Christ. He said to Edwin, 'Believe me, my brother, if the cursed woman who seduced the girl into marrying were to come to me for confession, I would give her the same penance as if she had killed someone. But as for the blessed girl who was married in these

circumstances, her I would absolve without a moment's hesitation. Indeed, I absolve her now, and as the deputy of Christ, the high priest, who gave me that power, I give her my blessing. And now I urge her to continue in her vow of virginity, and I ask God to bring to fulfilment that angelic desire which he himself inspired in her. But you, Edwin my son, must not delay here, but hurry home and comfort the precious dove of God with all the help and counsel you can, and may the Lord be with both of you.'

So he joyfully set out for Huntingdon, speaking with hermits at various places on his way home. When he arrived, he found Autti and his wife and children at the monastery of Our Lady. Christina was there with them, watched over carefully by them all. So, although she could see her helper, she could not speak to him. Indeed she did not dare give the slightest suggestion that she had noticed him, although, of course, she was longing to know what had been decided about her on his trip. As later I was often to hear her say, if she had been offered a chance of speaking to the hermit on the one hand, or of being given a hillock of gold as large as the monastery she was sitting in, she would have renounced the gold unhesitatingly in order to be able to speak to him then. Coming home miserably with her parents, she asked her sister Matilda the next day to get Edwin to come to see her, but was brusquely refused. As a result of a giving a bribe, though, she was able to say a few words to Edwin's servant. This boy had travelled with Edwin and knew what his master had been trying to do. The girl, learning from him that there were several possible hiding places open to her, chose Flamstead because it was near Roger, whose servants were in frequent contact with a recluse locally

whose name was Alfwen, a woman very much loved by Roger because of her holiness. When he was talking to the servant, the boy said, 'I wish you were safely with me outside the town.'

This made Christina blush with embarrassment, not only because it would be unseemly for a daughter of Autti to be found alone in the open countryside with a young man, but also because she knew how difficult it was to escape from the vigilance of her keepers. But she was touched by his obvious goodwill towards her and instructed him, 'Go and tell your master to prepare two horses, one for me and one for you, at a such-and-such time' – and she fixed on the day of the week. 'As the dawn comes up, wait for me with the horses in the field over there,' and she pointed to the spot with her finger. 'I will come to you there. Do not make a mistake and hail someone else instead of me. When the horse is ready you will recognize me by this sign: I will place my right hand to my forehead with only the forefinger raised. As soon as you see this, rein in the horses at once. And if I do not come over to you straight away, assume that I am waiting for a suitable moment. On that day my father and mother will go, as they usually do, to visit Guido.' Guido lived in a secluded place about six miles away from the town. Carefully making a note of all this, the boy returned, and repeated the details to his master. He was pleased, and prepared the horses and everything else that was needed.

The chosen day came. When her parents had left for the country, Christina went down to the river, carefully looking across the meadow to see if her helper was there. When she could not see him she assumed he was held up, and went on to the church of Our Lady the Virgin to ask

Sueno for permission to depart. She did not find him, but did all the other things she had in mind. For example, she prayed to God that her helper would come quickly, and that her eventful journey would be successful. Then she visited her aunt, whose love for her, increased by generous presents, was such that she would not betray her, but do her best to help her to escape. So, under her eye, as it were, she was free for that day, unhindered by watchers. When she explained about the lateness of her helper, her aunt comforted her. All the time she kept watching the field beyond the river, terrified her parents would return at any moment, and again she visited the church of Blessed Mary. On her way she met the reeve of the town accompanied by some citizens. And he held her mantle and begged her to tell him whether she intended to run away. And she smiled and said: 'Yes.'

'When?' he asked.

'Today,' she replied.

When he let her go she entered the church and, prostrating herself, prayed with great pain in her heart, 'O Lord my God, my only hope, the one who sees into all hearts and feelings, whom alone I wish to please, is it your will that I should be disappointed in my wish? If you do not save me today I shall remain in the world, anxious about the things of this world, and how to please my husband. My only wish, as you know, is to please you alone, and to be united with you for ever, world without end. But your will will become clear to me today if you send me away from my father's house and all my relatives, never to return. For it would be better never to leave that place than to be forced to return like a dog to its vomit. But you alone know what is right for me. I ask not my will but

yours now and for ever. Blessed be your name for evermore.' When she had said this, she stood up and left the church.

And searching the meadow beyond the river once again, and not seeing the man she longed to see, she went home and sat down among her mother's servants, sad at heart and worn out with disappointment. She was already beginning to lose hope, when suddenly something, like a small bird full of love and joy, moved rapidly inside her as if fluttering in her breast. And she felt as if it flew upwards towards her throat uttering these words: 'Theodora, get up. Why are you so slow? Look and see! Loric is here!' (Loric was the boy's name.) Trembling at the strange voice, she looked around to see if those in the room had heard it. And when she saw them all busy at their work, she jumped up at once, full of confidence in the Lord. And secretly dressing in men's clothes, which she had prepared beforehand in order to disguise herself, she went out wearing a long cloak over them that reached to her heels. But when her sister Matilda saw her hurrying away, and recognized her from her clothes, she followed her. Christina, realizing this, pretended that she was going to the Church of Our Blessed Lady. But as she walked, one of the sleeves of the man's dress which she was wearing beneath her cloak slipped to the ground, whether through carelessness or on purpose I do not know. And when Matilda saw it she said, 'What is this, Theodora, that you are trailing after you?'

But she replied with an innocent look, 'Dear sister, take it with you when you go back to the house for it is becoming a nuisance.' And she handed over to her a veil and her father's keys, adding: 'And these too, dear one, so

that if our father returns while I am gone and wishes to take something from the chest, he will not get upset because the keys are missing.' And when she had calmed Matilda's suspicions with these words, she set off as if she was going towards the monastery, and then turned back towards the meadow.

Revealing herself by raising her finger to her forehead, she was met by her companion with the horses. Taking one of the horses, she paused, overcome by embarrassment. Why wait, poor fugitive? Why worry about betraying your womanliness? Put on the spirit of manhood, and sit your horse like a man. With this thought she overcame her fear, and jumping astride the horse like a youth she set her spurs to the horse's sides, saying to the servant: 'Follow me at a distance. I fear that if you ride with me and we are caught, they will kill you.'

It was about nine in the morning and they reached Flamstead about three in the afternoon, having travelled more than thirty miles. There she was joyfully welcomed by Alfwen, the elderly anchoress, and on the same day she put on the religious habit. Accustomed to wear silk garments and rich furs in her father's house, she now wore a coarse dress. Hidden away in a rude chamber hardly big enough to hold her, she remained carefully concealed there for a long time, taking great joy in Christ. And on that day she took for her reading five verses from the thirty-seventh psalm, of which the first runs, 'Lord, all my desire is before you.' A very apt passage, and one that perfectly described her feelings. She said it over again and again, grieving at one moment over her own weakness and blindness, at another over the cruelty and deceit of the parents, friends, and relatives who were seeking her

life. But first she prayed to the Lord to deliver her from all these, so that, free of terror, she might serve him in holiness and righteousness all the days of her life.

Meanwhile, her parents had returned from the hermitage, and when they could not find Christina at home nor among the recluses of Huntingdon nor at the monastery of Our Lady, they finally realized that she had run away. They could not make out where she had gone. So they immediately sent out search parties along all the roads that led to Huntingdon with orders to pursue and catch her and to bring her home in disgrace, killing anyone they found with her. While some went furiously searching in one direction and some in another, her husband Burthred, suspecting that she was hiding with Roger the hermit, went to his hut and asked one of his disciples whether there was a woman there, bribing him with two shillings to show him where she was. Angrily the man replied: 'Who do you think you are, expecting to find a woman here at this time of night? It is very unusual for a woman to be allowed in here even chaperoned and in daylight, and you expect to find one here before dawn?' So Burthred hurried off to Flamstead to talk to the venerable Alfwen, who told him: 'Stop imagining she is here with us, my son. We are not in the habit of sheltering wives who are running away from their husbands.' Burthred, thus deceived, left, determined never to attempt such a quest again.

That same day at about three in the afternoon while Roger was sitting at table eating his meal, his servant said to him, 'That fellow who was here today before dawn looking for a girl did not know you very well.'

'Who was it?' he asked.

'I don't know,' the servant replied, 'but he came from Huntingdon and was looking for a girl of noble family who, he said, had run away from her father and her husband.'

Roger groaned and ordered the table to be cleared, and then he went fasting to his chapel, where day and night, giving himself up to lamentation and tears, he neither ate nor drank until, worn out with sorrowing, he sank down on his bed saying: 'I know, Almighty God and stern judge, that you will require her soul at my hands. For I knew that her intention was good, but I was unwilling to give her my support when she asked for it. Now some man, driven by the devil, has led her astray with worldly cunning, and destroyed her in her foolishness.' And he could not rest while he was uncertain of what had happened to Christina, so he prayed unceasingly to the Lord to give him a sign.

After some days, one of the members of his household, called Ulfwine, went, as he often did, to seek the advice of the venerable Alfwen, and learning from her of the arrival and concealment of Christina, he returned to tell the whole story to his master Roger. When Roger heard it, he broke into rapturous thanks to the Lord and said to Ulfwine: 'This day you have called me back from the depths. May the Lord who made heaven and earth be blessed out of Zion.'

Further, when Sueno the canon found out about the departure of Christina, he strongly reproached her mother for having driven away the one for whom God had blessed her house. 'Know, therefore,' he said, 'that your house will suffer many hardships in the future, especially from a terrible fire.' All of this later came to pass as the man of God had said it would.

While all this was going on, Alfwen discovered and told Christina that the young man who had helped her to escape was being sought by her parents in order that they might punish or even kill him. And all her friends were distressed at this, and prayed to the Lord for the youth's safety. Then one night, when Christina was barely awake, he stood beside her with shining face, and reproached her for her baseless fears about those who were seeking her, telling her to put all her trust in the Lord, her protector. Next morning, when she described the vision to Alfwen who was hiding her, and said how she would be safe, a young man came to say that the youth had passed away in a deeply Christian death. They knew, therefore, that the one who had looked so beautiful and had advised her to trust in God and fear nothing from men, was now sharing the company of the elect.

In addition she had another vision which comforted her. She saw herself standing on firm ground in a large and muddy field full of bulls with threatening horns and glaring eyes. And as they tried to lift their hooves from the mud to attack her and tear her to pieces, their hooves were stuck in the ground so that they could not move. While she watched this with astonishment, a voice said, 'If you stand firmly in the place where you are, you will have no reason to fear the ferocity of the bulls. But if you retreat one step, at that very moment you will fall into their power.' She woke up, and interpreted the place as being her resolution to remain a virgin: the bulls were devils and wicked men. In a surge of elation, she was filled with a stronger desire for holiness, and became less frightened of the threats of her persecutors. Meanwhile her quiet, hidden existence irritated the devil; her reading and singing

of the psalms by day and night exasperated him. For
although in her hiding-place she was hidden from human
beings, she could not escape the attention of demons.
Toads overran her cell in order to frighten the dedicated
handmaid of Christ, and to distract her by their ugliness
from the beauty of God. Their sudden arrival, with their
big and horrible eyes, was terrifying, for they jumped all
over the place, squatting on the middle of the psalter,
which lay open on her lap at all hours of the day for her
use. When she refused to move and would not stop
singing the psalms, they disappeared, which makes one
think they must have been devils, especially as they
appeared unexpectedly. As the cell was closed and locked
on all sides it was not possible to see where they came
from, nor how they got in or out.

When Christina had spent two years at Flamstead she
had to go elsewhere. While she was getting ready to leave,
the sound of virgins singing was heard by Roger's two
companions Leofric and Acio his friend, as they were
themselves singing their usual praises to God. They won-
dered who it was, and being delighted by the melody, they
did not sing alternately, as was their custom, but sang the
same verse in unison. At the end of the verse they kept
silent and listened to the next verse being sung to a sweet
melody by the other choir. Frequently a whole psalm
would be sung completely by the men and the maidens in
this way.

They spent a lot of time wondering about the meaning
of this, and eventually it was partly revealed to Roger in
prayer. He summoned Acio and Leofric to him immedi-
ately and said to them: 'Prepare yourselves and be certain
to be worthy of the visitation of God. For I know that

God will soon come to this place, sending here someone whom he loves dearly. Who it is I cannot tell. All I know is that it is someone dearer to him perhaps than sinners like us.'

A few days later, while Roger was remembering the discomforts that Christina endured at Flamstead not simply patiently but even with joy, and judging from these and other traits that she was deeply rooted and grounded in the love of God, he decided that he would no longer refuse to help her. And so he agreed to have her cell brought near to his own in spite of Alfwen's disapproval. Even so he would not consent to look at Christina or to speak to her, or only indirectly through Acio, so that Alfwen would not be in a position to accuse him to the bishop as a cause of disquiet.

But as it happened the two of them saw each other that very day, and it occurred like this. The virgin of God lay prostrate in the old man's chapel, with her face turned to the ground. The man of God stepped over her with his face averted in order not to see her. But as he passed he glanced back to see how the handmaid of Christ composed herself for prayer, as this was one of the things which he thought those who pray should observe. She, at the same moment, glanced upward to see the bearing and character of the old man, for in these things she thought that some sign of his great holiness could be seen. And so they looked at each other, not intentionally, yet not by chance, but, as later became obvious, by the will of God. For if they had not seen each other, neither of them would have dared to remain with the other in the confined space of the cell. They would not have lived together, nor would they have felt divine desire, nor reached such heavenly

heights. In short, the fire which had been lit by the spirit of God and burned in each of them, threw its sparks into their hearts by the grace of that mutual glance. At once they were made so at one in heart and soul, in chastity and charity in Christ, that they were not afraid to live together under the same roof.

Further, because of living together and encouraging one another to strive after higher things, their holy love grew day by day, like a great flame rising from two brands held together. The more keenly they longed to contemplate the beauty of the creator, the more happily they reigned with him in sublime glory. And so their great prowess made it possible for them to live together. Yet they behaved circumspectly in not letting this be widely known, for they feared scandal among the simple faithful and the anger of those who were still persecuting the handmaid of God. Near the chapel of the old man, and joined to his cell, was a room which made an angle where it joined on. This had a plank of wood placed in front of it and was so hidden that to anyone looking from outside it would seem that no one could be inside it, since the space was not bigger than a handspan and a half. In this prison, therefore, Roger placed his cheerful companion. In front of the door he placed a heavy piece of wood, which was so heavy that it could not be put in place nor taken away by Christina herself. And so, confined in this way, the handmaid of Christ sat on a hard stone until Roger's death, that is, for four years or more, hidden even from those who lived with Roger. Oh what miseries she had to endure of cold and heat, hunger and thirst, daily fasting! The confined space made it impossible even to wear enough clothing when she was cold. The airless little

hole became stifling when it was hot. Through prolonged fasting, her bowels became contracted and dried up. Once her burning thirst caused little clots of blood to bubble out of her nostrils. But what was more intolerable than all was that she could not go out until evening to satisfy the needs of nature. Even when she was in desperate need, she could not open the door for herself, and Roger usually did not come until late. So she had to sit quite still in the place, to endure agony, and to keep quite quiet, because if she wished Roger to come to her, she had to summon him either by calling or knocking. But how could she do this from her hiding-place when she hardly dared to breathe? For she did not know whether someone else besides Roger might be at hand, and, hearing her breathing, discover her hiding-place. And she would sooner die in the cell than make her presence known to anyone at the time.

After suffering these and many other harmful things for a long time, she developed a number of ailments, which increased from day to day until they became incurable. Yet although human medicine could bring her no relief she was, as we were to see many years later, cured by an unexpected grace from God. She endured all these daily problems and troubles with the sweetness and equanimity of divine love.

In those hours at night when she was free to concentrate on prayer and contemplation, she prayed intensely, just as her friend Roger had taught her, both by word and by example. He had taught her heavenly secrets which are almost unbelievable, and behaved as if he were on earth only in body, whilst his mind was entirely fixed on heaven. You may think that perhaps this is an exaggeration if I do not add proof to confirm what I say. She of whom we

are writing and who was the old man's companion has told me once, when he was caught up in prayer, his concentration was so complete that the devil, invisibly angered, visibly set fire to the cowl that lay across his back as he prayed, and even by this he could not distract him. What do you imagine must have been the fire that burned inside him since it made his body indifferent to a fire that burned outside him? You must believe therefore that Christina herself was no less on fire when she stood beside the man of prayer. Every day he took her into his chapel for this purpose. They constantly wept tears of heavenly desire and fed on rare delights of inner joy.

To begin with they were haunted by a fear, a very real one, which spoiled their pleasure, that if it chanced that Christina was found in his company she would be snatched away on the bishop's orders and handed over to her husband to do as he liked. The old enemy did not stop stirring up these two villains, and any others he could involve with them, to discover where she had gone. Therefore she prayed endlessly for Christ's mercy in the matter. And not without result. On the day of Our Lord's annunciation, while Christina was sitting on her stone and worrying about the frantic behaviour of her persecutors, the most beautiful of the children of men came to her through the locked door, holding a cross of gold in his right hand. When she saw him the girl was terrified, but he soothed her with these comforting words: 'Fear not,' he said, 'for I have not come to add to your fears but to give you confidence. Take this cross, therefore, and hold it upright, slanting neither to right nor left. Always hold it straight, pointing upwards, and remember that I was the first to bear this cross. All who wish to travel to Jerusalem

must carry this cross.' Saying this, he held out the cross to her, promising that soon he would take it back again. And then he disappeared.

When Christina described it all to Roger, the man of God, he understood its meaning and began to weep for joy, saying, 'Blessed be God, who cares for his lowly ones at all times.' And he said to the girl in English (he usually spoke in Latin), 'Rejoice with me, myn sunendæge dohter,' that is, my Sunday daughter, because just as Sunday exceeds the other days of the week in dignity, so he loved Christina more than all the others whom he had conceived or cherished in Christ. 'Rejoice with me,' he said, 'for by the grace of God your troubles will soon be over. The meaning is this: the cross which you have received as a token will soon be taken away from you.' And it happened as the man of God had said.

Two days later, on 27 March, the day on which the Redeemer of the world rose from the dead, Burthred came to Roger's cell with his two brothers, one a canon, the other a layman, humbly asking to be pardoned. He knew, and was prepared to admit, that he had gravely sinned both against Roger, and more especially against Christ's handmaid, Theodora. He came now, he said, to release her from her marriage vows and to submit himself to the instruction of the old man. He claimed this command had been given to him by Mary, the mother of God, queen of the world, who two nights previously had appeared to him in a terrible vision, sternly rebuking him for his pointless persecution of the sacred virgin.

Roger, realizing that the two men who accompanied Burthred had little public standing, sensibly offered and obtained a few days' respite while he thought the matter

over and Burthred found other witnesses. At the end of the period Burthred came back and, as he had been instructed, released his wife, placing his right hand in Roger's, and promising and confirming her release in the presence of the following priests, that is to say, Burthred who had married the couple, Robert, dean of Huntingdon, Ralph of Flamstead, and five hermits who lived with Roger. After this the man of God felt safer. Thinking of the many virtues which he had seen Christina to possess, he hit on the idea of leaving her as his successor at his hermitage. He sometimes talked to her about this. She thought that it might be beyond her capacities, but neither refused not accepted immediately, but in her usual way placed both this decision and herself in the hands of the Lord and the Virgin Mary. Whereupon a wonderful thing, more wonderful than wonder, happened. Once when she was praying and was weeping in her longing for heaven, she was suddenly caught up above the clouds to heaven, where she could see the queen of heaven sitting on a throne and glorious angels seated about her. Their brightness exceeded that of the sun by as much as the brilliance of the sun exceeds that of the stars. Yet the glory of the angels could not be compared to the light which surrounded her who was the mother of the most high. Can you imagine the brightness of her face which outshone all the rest? Yet as Christina gazed, first at the angels and at the mistress of the angels, by some marvellous faculty she found it easier to see through the splendour that shone about the mistress than through that which shone about the angels, though the frailty of human sight usually finds brighter things harder to bear. She saw her face more clearly than those of the angels. As

she gazed fixedly at her beauty and was more and more delighted at what she saw, the queen turned to one of the angels in attendance and said, 'Ask Christina what she wants, because I will give her whatever she asks.'

Christina was standing near the queen, and clearly heard what she said to the angel. And, prostrating herself, she saw in a moment the whole vast world spread before her. But first she sought Roger's cell and chapel which she saw beneath her shining radiantly, and she said, 'That is where I wish to dwell.'

'She shall have her desire,' answered the queen, 'and could have more if she asked for it.'

From then on, therefore, she knew that she would succeed Roger as his successor. As a result Roger was concerned in the eyes of both God and men to find a patron and the necessities of life for his successor. Eventually he thought of Archbishop Thurstan of York, who was known for his support of holy vocations, and sent to him to ask what should be done about Christina. Thurstan asked to have a private interview with her. So the old man sent for Godescalc of Caddington and his wife, people very close to his affections and of good family, who lived a happy married life under Roger's spiritual direction. He explained to them how, and for what reason, he was asking them to conduct Christina to Redbourn.

When they had agreed to take her and received permission to go, the man of God said to them, 'Go in confidence because I shall pray for you, and you will not perhaps be sorry at the trouble you are taking for God and his handmaid.' They set out, therefore, mounted on only one horse. As the animal toiled up a steep incline through a wood, the girth broke and the saddle fell to the ground

with the riders on it. What could they do? Night had come, the horse had run away, they were elderly and all alone. Even by day they could not have caught up with the horse. Eventually, leaving the saddle behind, because it was too heavy for them to carry, they began to travel on foot, groping along in the dark as best they could. When they became tired, sadness overcame them and they grumbled, 'What has happened to the promise of the man of God?'

They had scarcely spoken before a horse, saddled and bridled, stood beside them, quiet as a lamb, near a fallen tree trunk which seemed placed there to help the servants of God to mount. When they saw it, they gave thanks to God and his servant Roger, and, mounting the horse, set off for home. Next day Godescalc returned to Roger, took Christina and led her secretly to the Archbishop at Redbourn. The Archbishop spoke privately with her for a long time, and learning from her what she needed, he took her into his keeping from then on, and made a promise which he later carried out, that is to say, the annulment of her marriage, the confirmation of her vow, and permission for her husband to marry another woman by apostolic permission. Then he sent her back home.

Christina therefore remained with Roger at his hermitage until his death. But when he died, resting with God after so many trials, it was necessary that Christina should leave to avoid the anger of the bishop of Lincoln. Therefore after she had tried various hiding-places, the Archbishop recommended her to the care of a certain cleric, a close friend of his, whose name I am not allowed to give. He was both a religious and an eminent man in

the world, and depending on these things Christina felt safe in living with him.

To begin with they had no feelings about each other except chaste and spiritual ones. However, the devil, the enemy of chastity, did not like this, and used their quiet domesticity and sense of security to insinuate himself, at first secretly and ingeniously, and then, later, to launch a full-scale attack on them. Shooting his fiery darts, he pressed his attack so strongly that he won the man over. He could not conquer Christina, although he attacked her flesh with temptations to pleasure and her mind with sensual thoughts. He used her living companion to lead her many a dance. Sometimes the wretched man, beside himself with passion, appeared naked before her and behaved so outrageously that I cannot speak of it lest I pollute the wax as I write it, or the air by speaking it. Sometimes he fell to the ground at her feet, begging her to look lovingly upon him and pity his unhappy state. But as he lay there, she rebuked him for neglecting his calling, and with stern reproaches repulsed his pleading. And although she was herself struggling with strong feelings, she sensibly pretended that she was unaffected. So that he sometimes jibed that she was more like a man than a woman, though she, with her disciplined masculine behaviour, might more justifiably have called him a woman.

Notice the manful way she behaved in such a time of danger! She resisted the desires of her flesh violently, in case her own body should become an agent of wickedness against her, with long fasting, only a little food consisting of raw herbs, a cup of water to drink, nights without sleep, painful scourgings. What was even more effective than these ordeals, intended to weaken and tame her

lustful body, was that she called upon God unceasingly not to let her, she who had taken a vow of virginity and had refused marriage, be lost for ever.

Only one thing eased the situation – the actual presence of her companion which caused her passion to die down. (In his absence, on the other hand, she felt so excited at the thought of him that she felt as if the very clothes she wore might ignite. If this had happened while he was there she might well have been unable to control herself.)

Once, as she was going to the monastery, the cleric, her evil genius, appeared to her in the form of a huge, ugly, furry bear, trying to prevent her from entering the monastery, for nothing staved off his attacks so effectively as the prayers and tears of the humble and ascetic girl. But as she walked away, the earth opened up at the feet of her wretched enemy. This the girl reported. As a result of this she was ill for a fortnight or more.

And yet the shameless priest did not stop harrassing the sick girl with as much persistence as he had done when she was well. Eventually one night he saw three saints in a dream, John the Evangelist, Benedict the monastic founder, and Mary Magdalen, accusing him in his sleep. Mary, for whom the priest had a particular regard, frowned at him, and reproved him sternly for his wicked persecution of the chosen bride of the most high king. And she threatened him that if he bothered her any further, he would not escape the wrath of almighty God and eternal damnation. Awake now,. and terrified at the vision, he went to the girl in a very different mood, and telling her what he had seen and heard, asked for, and obtained, her forgiveness. After this he changed his life.

Neither this, however, nor anything else, cooled the

ardour of the virgin, which he had aroused. After endless struggling against the wiles of the tireless enemy, sick and tired of her unfortunate lodging, she returned to the pleasant place in the wilderness given to her by the queen of heaven. Day and night she knelt in prayer, weeping and lamenting and asking to be freed from temptation. Even in the wilderness she still felt its stings.

Then the son of the Virgin looked gently down upon the low estate of his handmaiden, and granted her the comfort of an unheard-of grace. For in the form of a small child he came to the arms of his suffering bride and remained with her a whole day, being both felt and seen. So the girl took him in her hands, gave thanks, and pressed him to her heart. And with unspeakable joy she held him at one moment to her virgin breast, and at another she felt his presence inside her even through the barrier of her flesh. Who can describe the astonishing sweetness which the love of her creator gave to his servant? From then on the fire of lust was so completely burned out that it never again revived.

About then the bishop of Lincoln, Christina's most virulent persecutor, died. After long punishment his life was severed by sudden death, and his salutary example discouraged others from persecuting the virgins of Christ.

The girl therefore now lived happily in her solitude free from fear. She used the peace she had so long sought to meditate on the mercy of Christ which had delivered her from so many dangers. Being astounded at the greatness of the grace granted to her, she offered up a sacrifice of thanksgiving every day to her deliverer. This was her one joy, her sole purpose, to devote herself to praising God and giving thanks.

Meanwhile the Lord decided to show how great was her merit in his sight. There was a woman of Canterbury of good family, who was dear to her parents. She suffered from an infirmity called the falling sickness, which had appeared as a result of her own folly when she was already grown up, and she had become so difficult for her family that they had cast her out. She suffered this condition every Tuesday at nine o'clock for two years. In the third year of her wretchedness the blessed martyr and virgin Margaret appeared to her, sent by God, who in a vision advised her to go to God's friend Christina, then living in the hermitage not far from St Albans monastery, and to drink water which Christina had blessed with her hands in the name of the Blessed Trinity. She would then recover her former health.

Full of hope, the woman left without delay and came at once to see Christina. She first confessed her sin to her, then her unhappiness, thirdly the vision she had had, and finally she begged for a cure. Christina, however, refused, saying that this was not her concern, that the woman had not been sent to her, and that she may have been deluded by her dream. Rebelliously the woman persisted in her entreaty, asking the help of Alfwen, a priest, and some others who were there. And though they all pleaded with Christina for a long while not to be stubborn, nor to deny the grace of God which was waiting to effect a cure, she would not consent until they had promised that the priest should celebrate Mass, while the others would join her in praying for the intervention of God in the matter. She did this to ensure that the grace of recovery should be put down to their virtue, not to hers.

On Tuesday morning, therefore, they gathered together

in the chapel and prayed to God, while Christina blessed water and gave it to the woman to drink. During the canon of the Mass an ancient but handsome man, holding a book in his hands, came towards the woman and stood before her, opening the book. Christina, who was the only person present to see this, realized that Christ had sent his Apostle to cure the woman. When Mass was over, she told her so. Longing to believe, but full of doubt, the woman stayed in the chapel trembling until nine o'clock. In fact she stayed there until noon. Then, seeing that the dreaded hour had passed without a seizure, she knew at last that she was cured. And weeping freely from joy, she asked them all to give thanks to her redeemer. After she had promised that, during the lifetime of Christina, she would tell no one how she was cured, they sent her away.

Christina, who achieved cures for others from heaven, herself suffered from many painful ailments which she had acquired through the various hardships she had endured. As she grew older new ones were added to the old. They were all incurable (everything known to medical science had been tried), but she was cured at last, quite unexpectedly, by divine intervention. But first, listen carefully how appropriately Christ cured her of one sickness, and that the worst, through his mother, and then how wonderfully he cured her of all the rest together, by sending her a crown from heaven to symbolize her virginal integrity. The sickness, which they call paralysis, affected half of her body, moving from her lower limbs to the top of her head. As a result of another illness her cheeks were already swollen and inflamed. Her eyelids were sunken, her eyes bloodshot, and beneath one eye you

could see a nerve flickering without stopping, as if there was a little bird inside fluttering with its wings. Famous doctors were sent to her because of these symptoms, and to the best of their ability they practised the physician's craft, with medicine, blood-letting, and other sorts of treatment.

The treatments they thought would help her, however, had precisely the opposite effect. In fact the sickness, which they had attempted to cure, became so acute that she suffered from it for five whole days without stopping, so that what her state of health had been in comparison with her suffering before treatment, now her illness became in comparison with the suffering that followed. In order to help her, an old man sent her a tablet, which, dissolved in wine and drunk, would, he claimed, eradicate the illness. But so that the bride of God might have faith only in divine help, her subsequent suffering became worse than it had been before. So severe was it by the sixth day that she was expected to die at any moment. But the next night, by the will of God (who rested on the seventh day), when she awoke she found herself restored to health, and, thank God, to our company. For regardless of what hour she was freed from the prison of her flesh, who could doubt that her Bridegroom would come and take her with him to the nuptials? Feeling movement in her eyelids, sight in the eye which had been blind, the swelling gone from her cheeks, and movement in the other limbs of her body, and barely able to believe such a surprising turn of events, she called her handmaidens together and celebrated the occasion with a lighted candle. The next day, when they had come together, they all talked about the sudden cure of their mistress.

One of them remarked that, in the first watch of the night, she had had a dream in which she had seen a woman of great authority, with a shining face, whose head was veiled in a snow-white wimple, embroidered in gold thread and fringed at each end with gold. And she saw her sit down beside the patient's bed, and take out a little box in which she had brought a tincture of unusual fragrance. While she was carefully preparing to give it to her, the watchers with tears in their eyes warned her, saying, 'Do not waste both your medicine and your labour, lady, because we saw the woman you are trying to cure barely escape death after taking a similar dose yesterday.' But she paid no attention to what they said, and carrying out her errand, gave the medicine to the sick woman and cured her. The patient who was cured, and the handmaid who had had the dream, discussed both cure and vision with all the greater joy because one had been unaware of the vision, and the other of the restoration to health. You see how easily and naturally God cured his virgin daughter with heavenly medicine through his virgin mother, medicine made by mortals being unworthy of his bride.

I must now describe how she was freed from her other ailments, for there were many of those. Each of them was worse in its way than the paralysis. As there was a real danger they would kill her at any moment, she did not wish to die until she had been religiously professed. At this time she had numerous visits from superiors of celebrated monasteries in distant parts of England and overseas, who wanted to whisk her away with them, and bring fame and prestige to their houses by her general acclaim.

Above all, the Archbishop of York wished to honour her and set her up over the virgins he had gathered

together under his name at York, or if this did not succeed, send her across the sea to Marcigny, or maybe to Fontevrault. But she preferred our monastery, both because the relics of that famous martyr of Christ, Alban, lay there (whom she loved more than the other martyrs there whom she revered), and because Roger the hermit was a monk there and was buried there. Also because, as you know as well as anyone, she deferred to you more than to any pastor under Christ and because there were in our community souls whom she loved more than those of other monasteries, some of whom owed their monastic vocations to her. It must be remembered that just as our holy patron St. Alban was given her by the Lord as his assistant in building up and developing his community on earth, Alban later was to have her as sharer of his eternal joy in heaven.

For reasons such as these Christina made up her mind that she would make her profession in this monastery and would receive her consecration from the bishop. But in her heart she was very troubled, not knowing what she should do, or what she should say, when the bishop asked, during the ceremony of consecration, about her virginity. She was all too aware of the desires and yearnings of the flesh by which she had been troubled, and even though she knew she had not given way in fact or in desire, she was uneasy of claiming that she had escaped unscathed. At last she prayed to the most chaste mother of God with her whole heart, pleading with her and asking to intercede for the overcoming of her uncertainty. When she did this she began to feel better about getting permission, and she hoped it could coincide with the feast of the Assumption of the mother of God. Because of this she had no peace

until the feast day came. The nearer it came, the more anxiously did Christina worry about the delay. At last the day came, but her hopes were not fulfilled. The first day passed, and the second, and then all six days of the festival. Christina never ceased to pray, and in fact her determination and hope grew as the days passed.

On the seventh day, that is 21 August, about cock-crow and before dawn, she got up and stood beside her bed. The hour had passed at which Nocturn is usually sung. Thinking this was due to the nuns oversleeping, she saw that, unusually, all of them were fast asleep, and that the convent was wrapped in deep silence. While she remained transfixed in astonishment (an act of kindness of the divine condescension), suddenly there gathered about her young men of great beauty. She knew that there were a number present, but she could only see three. Hailing her, they said, 'Greetings, virgin of Christ. Jesus Christ, Lord of all, sends you greeting.' And then they came closer and standing in a circle round her they put on her head a crown they held, saying, 'This is a gift from the Son of the most high King. You are one of his own. You are astonished at its beauty and craftsmanship, but it would seem as nothing if you knew the art of the craftsman.' It was, she said later, whiter than snow and more brilliant than the sun, of indescribable beauty, and made of a material she could not identify. From the back of it and reaching down to her waist were two white fillets, like those on a bishop's mitre. Crowned, Christina stood, surrounded by the angels who had been sent, from cock-crow until the day grew hot with the rising of the sun. Then, when the angels withdrew, she stood alone, knowing now, because of the heavenly crown, Christ had kept her unharmed in

body and mind. In addition, she felt so well that never again did she feel the slightest pain or discomfort from any of the ailments which had troubled her previously.

Annoyed by all this, the devil started a new offensive, afflicting the friend of Christ with terrifying apparitions and obscene images so badly that for many years, whenever she settled down to sleep, she dared not lie on her side nor look about her. She feared that the devil might suffocate her, or persuade her by his wickedness into improper behaviour. But when he failed in his endless attempts to corrupt her, the poisonous creature conspired to break her down by starting false rumours and broadcasting new and hair-raising slanders about her through the cruel tongues of his friends. People with mean minds, driven by malice, and persuaded by him who was always a liar, enjoyed spreading every imaginable tale against her, each of them thinking better of himself the more cleverly he made up lies about Christina.

The virgin of Christ, consoled during all this by her good conscience, gave herself up to the love of her redeemer, and submitted her cause to the judgment of God. In order to obey our Lord's teaching, she prayed for those who reviled her. Seeing that all his wiles were made useless by Christina's faith, and that someone possessed, as she was, by the love of God could not be subverted by the love of this world, the devil set out to use every trick he knew in his active and pitiless war, and finally attacked her with the spirit of blasphemy. He felt sure that if he could obscure her faith with darkness he would triumph. He approached in secret ways and put vile thoughts into her head. He intimated horrible thoughts about Christ, sickening thoughts about his mother, but Christina

refused to listen. He forced home his attacks, but was routed. Even then, nothing would scotch him. When beaten he would not go away, when defeated he would not retreat. Assuming new and more subtle weapons of temptation, he attacked the girl even more vigorously, resentful at finding an inexperienced young woman more than a match for him. When she was alone in chapel he harrassed her with such sordid visions, and alarmed her with such frightening threats, that anyone else might well have gone out of their mind.

Troubled by these and other problems the handmaid of Christ felt shaken to her roots, and became afraid that God might have abandoned her. She had no idea what to do, where to turn, or where to go, in order to avoid the schemes of the devil. At last, pulling herself together, and bearing in mind the past mercies of God to her, she entered the church and, full of tears, as so often, placed herself in God's loving presence. But when she remembered that God punished all sin, she wondered whether her many desperate troubles might not be due to her own follies. She lay prostrate on the ground, lifting her mind to God, praying earnestly. She was afraid that if help did not come soon she would be tempted beyond her powers, though on the other hand it was said that God never allowed anyone to be tempted beyond their strength.

But while she was giving all her attention to prayer, and was caught up from earth to heaven, she heard (but how I do not know) the divine words, 'Don't be afraid of these horrible temptations, for the key of your heart is in my safe keeping, and I myself watch over your mind and the whole of your body. No one can enter unless I allow them to.' At once Christina felt relief from her ordeals, as if

they had never been. For the rest of her life, whenever she was troubled by temptation or exhausted by suffering, she thought of the key and at once knew divine consolation that confirmed Christ's promise to his handmaid. She continued, however, to suffer in the crucible of poverty, lacking those things the absence of which adds to, rather than reduces, virtue. Her beloved and generous bridegroom, the Lord, did not wish to give her a hundredfold harvest here on account of all that she had given up, in case earthly opulence should destroy her spiritual love. For her part she would not take what she needed from anyone unless the gift was prompted by spiritual love and holy piety. But when he who knew her inmost secrets thought it the right time to come to her aid, even in worldly respects, this is the way he did it.

In the neighbourhood of the hermitage lived a noble and powerful man, skilled in both religious and worldly knowledge, abbot Geoffrey of St Albans. In his early years as Father Superior he ruled the house in his charge very strictly and furnished it with rich possessions.

When fortune began to smile at him through gifts from his wealthy parents, he began to grow more arrogant than was proper, and depended more and more on his own judgment, neglecting the views of the monks, whom he overruled. He was entirely unknown to the maiden of Christ except by common gossip. She had never seen him and she knew very little about him. All the same, it was through him that God decided to make provision for her needs and it was through her that he decided to accomplish this man's full conversion.

This was how it started. One day the abbot decided to carry through a scheme which he knew could not be man-

aged without annoying the chapter and offending God. But as he was a man of relentless determination, it was always difficult to change his mind. When he had set out on one of his highhanded schemes, he often added stubbornness to determination. His idea, however, had not yet been shared with anyone.

There was a man at the monastery of St Albans, beneath the rule of the abbot, who had himself great natural authority and who was a friend of the virgin. He was called Alvered, and, being devoted to virtue, had not lost his life, but instead had transformed it. He appeared in a vision to Christina, carrying a lighted candle in his hand as a symbol that he was a friend of light, and he said, 'The Lord Abbot, Geoffrey, without consulting the chapter, has decided on a course of action' (which he explained) 'which is dangerous, for if he goes ahead with it he will offend God. I beg you to stop him. This is the instruction I bring you from God.' Having said this, he disappeared.

Brooding on what had occurred, the virgin was not sure whether she should act on the instruction or not. 'If I speak to him maybe he will not believe me. But if I do not speak to him about it, then maybe I will incur the wrath of God.' Since she feared God more than man, she summoned one of her close companions, and sent a message to the abbot describing what she had seen and heard, trying her hardest to discourage him from doing what he proposed. He became angry, seeing the message as nonsense, and sent the messenger back to the virgin with the counsel not to put her trust in dreams. All the same he was surprised that the virgin should know about something that so far was only in his own mind.

When she received the abbot's arrogant reply she pur-

sued her usual course, turning to God in fasting, vigils and prayers, begging that if she could not persuade him, the abbot should be diverted from his path by another. Nor did God despise the prayer of his beloved virgin.

To be brief. A night came when Geoffrey had decided in his overweening pride to carry out the business he had planned. He went to bed and got himself ready for sleep. But in the first watch of the night he saw several black and frightening figures standing around him, who assaulted him, threw him out of bed, struck at him, tried to strangle him, and in various ways attacked him. When he was ready to breathe his last as a result of his suffering, he turned his eyes and saw Alvered, his eyes and face full of anger. At first neither spoke to the other. But finding his courage, the Abbot said, 'What, my lord, do you want me to do?'

Alvered answered angrily, 'You know perfectly well. You have received a message and yet you have made no attempt to change your wicked course.'

'Holy Alvered,' said Geoffrey, 'have pity on me. I will not continue with what is wrong and from now on I will obey any message from Christina promptly.' At this Alvered disappeared, and as the torturers also disappeared, his suffering ceased.

Next morning, surveying his injuries, he thought he should waste no time. He called together all the brethren in the monastery who were in his confidence and explained the business to them in detail, promising not to go ahead. Praises to God were uttered by them, the holiness of the virgin was admired, and from then on her warnings and advice were carefully obeyed by the abbot. Remembering what he had promised, and unable to forget

his punishment, the abbot went at once to visit the virgin, frankly acknowledging his debt to her for the message, and thanking her for his escape. He promised to shun what was forbidden in the future, and to obey her commands. He also promised to protect her convent in future in return for her intercession on his behalf with God. This change of attitude was your doing, Christ, who, in pouring out your grace save your friends through the instruments that you choose.

This was the way your virgin was at last saved from the sting of outward poverty by the abbot, while your abbot was freed from the inner pain of spiritual poverty by the virgin.

Always after that Geoffrey continued to visit the servant of Christ, accepted her rebukes, followed her advice, consulted her about his doubts, shunned evil, and meekly bore her reproaches. Because he was very active in worldly affairs, but also knew his duty in caring for souls, this kept him very busy in a way which seemed to destroy the spiritual peace he was seeking. Sinking under his burden, he went to the handmaid of Christ to see if she could suggest a place of retreat, and he listened to her answer as if waiting for the divine oracle itself, remembering the Gospel – 'It is not you that speak, but the spirit of your father speaking in you.' Going to Christina discouraged, he always returned newly heartened. If he felt weary of the changes and chances of the world when he went to see her, he came home reinvigorated. He now lived gladly in the shadow of the one whom all lovers know, and when he grew faint in divine love, it was good to know that after visiting Christina his heart would grow warm again.

The virgin, recognizing that the abbot's life was

bearing new fruit, and that through the mediation of so humble a person as herself he had overcome temptation and was now trying his best to do good, cared for him with great affection and loved him with a strong but pure love. For she was by now so full of the Holy Spirit that she neither knew, nor wanted to like, the things of this world. Their love was mutual, but different according to their standards of holiness. He supported her in worldly matters; she commended him to God very carefully in her prayers. If anything, she cared more for his salvation than for her own, guarding his with such care that, surprisingly enough, the abbot, whether at home or away on business, could not go against God, either in word or deed, without her feeling it instantly in the spirit. Nor did she refrain from reproving him strongly in his presence, when she knew that in his absence he had sinned, thinking that the wounds inflicted by a friend may do more good than the flattery of an enemy. This becomes clear from their whole story.

After this, whenever he was tempted to sin, remembering that she was, as it were, present (knowing that almost nothing escaped her), he fought off the temptation with the shield of faith. And as God tests everyone whom he loves, so he tested the abbot with a grave illness even to the point of death. And though he put no trust in mankind, yet his hope in God was strong, through the mediation of the handmaid of Christ, Christina. One remedy he had, and that not an insignificant one: to commend himself to the maiden before he died. So he decided to send for her. Messengers and horses were prepared to send for her on the following day.

None of this was unknown to Christina. Just the day

before, one of his monks, a humble and devout man, had
come to see her saying that she should visit the abbot who
was sick. She replied, 'I have learned that one should not
carry lilies without reason.' She went into her little chapel
and prayed weeping to God that a clear answer both by
sight and hearing should be given her about the abbot's
health. She wore a short, sleeveless gown whenever she
left the enclosure of the hermitage. Leaving the chapel she
felt herself swept up and over the roof, and then she saw
Geoffrey, for whom she had prayed sitting alone, resting
his head on a staff which he carried with him because of
his illness. And she saw the monks of the monastery, and
two nuns, Margaret, the sister of Christina, a virgin of
holy simplicity and integrity, and Ada, who had chosen
Margaret as a companion when she went to visit her
mother, who was staying at Westminster. She was on her
return journey to visit the abbot who was dying. With
delight she heard the abbot's voice saying, 'If only it
would please our Lord Christ to let my lady Christina
know that we are sitting here together.'

'We agree,' said the monks.

Christina came back to herself and after Matins
prayed earnestly to the Lord to give a quick and merciful
end to the abbot.

Immediately the loving recipient of her prayers gave
back his health to the abbot, joy to the monastery, and a
faithful servant to the church. The venerable man, feeling
his strength returning, wished to see the virgin, but
though he longed for the consolation of her company, yet
reason overcame desire. On the following day, at day-
break, Margaret, already mentioned, came to her sister's
hermitage. After a prayer, having said Benedicite, as the

custom is, without saying anything else, Christina told her sister to tell her nothing, and then related to her everything that had happened in detail – how she had seen the abbot, what he had said, and what the others there had said. Margaret admitted she was right, was astonished at the whole incident, and gave glory to God who works through his saints.

When the abbot had recovered, grateful for all she had done for him, he returned to his beloved virgin, longing for the spiritual profit of her gentle conversation. Nor was his wish unfulfilled. Margaret had told him in detail how everything they had said had been known to her sister Christina in the spirit, and how she had heard it all from her.

He had a tremendous respect for the virgin, and saw in her something that was divine and extraordinary. From then on he continually sought her company, not minding the weariness of long journeys in comparison with what he gained from a meeting.

All the same, he scarcely, if ever, visited her without her knowing it beforehand and telling one of her companions. As she understood that he was doing his best to improve spiritually, she was so concerned on his account that she prayed tearfully for him constantly and, when speaking with God, thought more of him than of herself. As she herself admitted, there was no one else among the people she cared about for whom she prayed so devotedly or so naturally. This was why it was that she often anticipated the attacks and insinuations which the demons had arranged, and by vigilant prayer fended them off from her beloved (for this was what she used to call him), and struggled to hold him in a state of peace.

On the morning of Whitsunday, having summoned three of the young women who lived with her, (for the number of her adherents grew with her reputation), she prophesied that her beloved would visit her on that day. She instructed them to put everything in good order and to behave in a seemly way so that her religious friend would not find anything there that offended him. Believing her, for past experience taught them she was right, they obeyed their mistress. The abbot was slow in coming. He had made up his mind to tell nobody of his visit, so that, if it could be managed, the virgin would not know. Mass was said, and still no messenger came from the abbot. The young women looked at one another, very surprised at the delay. But one thing was certain: Christina could not have misinformed them, nor made a mistake. Suddenly the appearance of a messenger gave them the cheerful news that the abbot was really coming.

The holy man arrived, and had a good and helpful talk with the virgin. While they were talking he said, 'This time I am sure my sudden arrival took you by surprise!' She called her sister Margaret, who knew all her secrets, and the others to whom she had mentioned the matter, and told them to own up about his visit. Obeying their truthful mistress, they admitted that she had known about it in advance. Everyone praised God, and the grace of the Holy Spirit was felt more freely on that day.

Christina lived for a long time in the hermitage before she chose the sign of humble virginity, and the bishop consecrated her in this sign. Many wise and holy persons, as well as friends and close acquaintances, encouraged her to place herself under obedience and to confirm her vow by solemn consecration, saying that it was right that

as her original vow had made her Christ's bride, so this should be symbolized in a ceremony. She delayed, not sure whether she should stay in the hermitage, since earlier she had thought of retiring to a distant place, where a town off the beaten track would offer a more secluded refuge. Eventually, inspired by God and by the gentleness and frequent urgings of the abbot already referred to, she agreed. And so, on the feast of St Matthew, who, it is claimed, was the first to consecrate virgins, the virgin of Christ was consecrated by Alexander, bishop of Lincoln.

In the fourth year after her profession, in the octave of Epiphany, the abbot was afflicted with severe pain and fever. In his compassion God arranged for him whom he had once beaten as a punishment, now to be beaten for the good of his soul. She who might have comforted his sickness was far away from the abbot at the time. However he sent word to his faithful protectress, asking her help in this crisis as in others. She went to her usual place, and throwing herself upon the ground, wept tears. As she cried out from her heart her prayers were heard by the Lord, and the health of the sick man was restored. Already deep within she felt the success of her prayers when a voice came from heaven saying, 'Know for sure that your beloved will come joyfully to see you in five days' time' (that was to say, Thursday). It was then Sunday. Coming quickly out of the chapel, she said to the messenger who was about to leave, 'Go home as fast as you can. When you both reach (a particular place) on the way back tell your master from me, "Tomorrow white stones will be thrown into the pot!"' This is a proverb quoted by worldly people when success is sure.

It was as if Christina were saying, 'By then, when your master has got better, he will hurry to see me.'

But he, convinced of his master's mortal sickness, replied, 'Mistress, this will not be. For he is suffering so much with sweating and at times with shivering cold that he can barely lie in bed, still less ride a horse.'

'Go,' she replied. 'Be assured of his recovery, and and do what I have said. But above all, please do not breathe a word of any of this until you get to the place I told you.' Obeying her orders, and doing his best to follow her instructions, he returned and found his master already somewhat better, but not contemplating a journey. He kept secret what he had been told to see if it would be verified by facts. Early on the day which Christina had mentioned, horses and retinue were prepared and they journeyed towards the virgin. They reached the spot Christina had designated, and then at last the servant gave Christina's message to his master. He was astonished.

'Did the virgin know', he asked, 'that my recovery would be so sudden and that I would travel today?'

'She knew,' the man replied, 'and she made it known with various signs.'

The wise abbot, confirming the present with past experience, was aware both of the Saviour's mercy and the woman's loving care for him.

One Christmas night, when she was meditating profoundly during Matins on this most important of births, and in her meditation became more and more moved with longing to understand it, there came to her the thought of her beloved friend. And as she was for some reason more anxious for him than for herself, a voice spoke to her, saying, 'Would you like to see the one for whom you are

anxious, and discover for yourself how he is?' And when she replied 'I would', she saw abbot Geoffrey (for we are speaking of him) wearing a red cope, his face glowing not with a simple brightness but with a shining quality transcending human beauty and glory. Christina was encouraged by this, and from then on became so deeply attached to him that neither favour nor spite could stop her from calling him her closest friend when it seemed right to do so. Nor did this happen without the wagging of tongues. For there were several who themselves wished to reach the same holiness of life and to be held in such affection by her as the abbot. But enjoying less of her affection, they concealed their disappointment by backbiting comments about her.

Two days later, on the third day after Christmas, when Alexander, the sub-prior of the church, visited her, he mentioned, when she brought the subject up, that the abbot had worn a white cope.

'Are you sure that that is so?' she said. 'On that night I was there in the spirit and I saw him wearing a red cope.' Then Alexander remembered with surprise that this was indeed the case, and glorified Christ devoutly in Christina. How she saw this vision, although she knows very well, we have never been able to get her to tell us up to the present day.

From about this period the abbot withdrew his hope from the world and fastened it all upon Christ. He gave himself up wholeheartedly to what might bring about this end, bravely renouncing the things of this world and yearning for those of heaven. All the same, unknown to men, he was cheered by one consolation which was to give his earthly riches to Christ's poor. Instead of seeking

unlawful gains, he spent what he had upon good deeds. What previously had been given over to worldly show, now he sought to give away secretly to hermits, recluses and people in need, as in the Apostle's testimony about 'having nothing yet possessing all things'. All this he attributed to the grace of God and the loving care of the virgin.

He became so different a man from what he had once been, that he who had once been obsessed with material pomp would not now go against God in small particulars for all the world. There was one thing that made him very curious about the virgin, and that was, by what purity or virtue in her such grace was granted her that with the aid of the spirit she immediately knew his deeds, however secretly or far away he did them. When he told her about them, she would answer, 'I know about that,' and would then tell him in detail what he was about to describe. He spent a lot of time thinking about it and turning it over in his mind, and he wondered how he could learn more. For if he ignored it he feared spiritual laziness in himself, and if he was too curious he feared to pry. He spent days, and some sleepless nights, pondering on these and similar problems.

One night, however, he saw himself in a vision holding a flowering herb in his hand, the juice of which was known to cure illness. If he squeezed it too hard, almost no juice came out, but if gently and slowly he could extract what he needed. Next day he went with a religious person, Evisandus, on a visit to his beloved hermit. Discussing the dream on the way, they interpreted the herb as Christina, and the flower as the gift of her virginity. He said what it meant was that she should be

approached subtly, attentively, not with thoughtlessness. This, later on, we often saw to be true.

Geoffrey told everything to Christina. At a very early hour, having heard the office, she came out of the church and walked in a little enclosure near at hand, filled with flowers. She picked the first flower, camomile, which she saw. Taking it gently in her hands, she went towards the abbot as he approached and, as she greeted him, said, 'This is the flower, am I not right, that you saw in your vision during the night?' And she showed him the plant. She had been told this by a voice which came to her from above.

The abbot and Evisandus were amazed at what they heard. Geoffrey described his vision, and the two of them outlined their conversation as they rode along, and they glorified God who reveals to the humble what he hides from the wise and prudent. So God in his mercy answered Geoffrey's problem, and made him love Christina even more.

Once it happened that the abbot was lying awake in bed in the early hours of the morning and thinking about urgent matters, and as he looked about him he saw clearly (it was not a dream), the virgin sitting near to him, clearly concerned to see how he related to God in his secret thoughts. He saw her, though he could not speak to her, but to his surprise and delight he spent a good night. In the morning when he got up he sent for one of his relatives called Lettice, whom he knew was visiting the hermitage that day. She was leading the life of a nun.

'Go,' he said, 'and tell your beloved mistress that her concern for me is known to me. For as I lay awake last night, I saw her enter' (and he mentioned the place and

time). For he thought that Christina would not know of it.

When Lettice arrived, she started to tell the message to the virgin of Christ. At the first word she replied, 'Say no more.' And she sent for her sister Margaret, the virgin of blessed memory (she wanted her as a witness in case Lettice should be suspicious). She ordered her, 'Tell me in front of Lettice what I said to you early this morning about that dream.'

Margaret answered, 'You said last night that at such a place and time Geoffrey's daughter had been to see him' (this was the way she described herself out of humility). 'And you said that if such a thing had happened in the time of blessed Gregory he would have written it down for posterity, even though it was a small thing. I said it was not small but something marvellous and worth remembering by those who came after us.'

When she heard this Lettice was deeply impressed, and glorified God in his saints. 'This is the Lord's doing and it is wonderful in our eyes.'

From then on the man devoted to good works visited the place more often than ever. He enjoyed the virgin's company, made financial provision for the house, and looked after its practical affairs. While he tried to help in every way with her material needs, she strove to care for his soul, praying so earnestly for him to God that while intent upon it she forgot the man's presence. After receiving the eucharist or during the celebration of the mass (for she communicated at the table of Christ whenever the abbot celebrated the divine mysteries), she was so caught up in rapture that, unaware of earthly things, she gave herself up to the contemplation of the face of her

creator. Knowing this, the abbot used to say, 'This is my glory, that when you are forgetful of me you lead me to him, whose presence is so lovely that you do not know I am present.'

Now the handmaid of Christ, training her mind by vigils and her body by fasting, besieged God in prayer and would not stop until she was sure about the certain salvation of her beloved. God listens to the prayers of the pure in heart, and even before his name is spoken, he is saying 'I hear!' This he chose to reveal in a vision. For Christina saw herself in, as it were, a room, attractive in furnishing, style and atmosphere, accompanied by two noble and handsome men dressed in white garments. Standing side by side, they were identical in stature and beauty. A dove more beautiful than other doves perched on their shoulders. Outside she could see the abbot trying in vain to reach her. Making a gesture with his eyes and head, he humbly asked her to introduce him to the men standing at her side in the divine presence. The virgin wasted no time in trying to help her friend with her usual prayers. With all the passion of which she was capable, with all the love within her, with all the devotion in her character, she begged the Lord to take pity on her beloved. At once she saw the dove flying through the room with small movements of its wings and pleasing her with its innocent look. When she saw it, God's servant took heart, and would not stop praying until the abbot either owned, or was owned by, the dove. When she recovered her ordinary way of seeing, she realized that the dove stood for the grace of the Holy Spirit, and that once the abbot was filled with it, he would only long for heavenly things. Filled with delight at this knowledge, she cherished him,

and honoured a fellow and companion of heavenly and
not earthly glory, and cared for him even more deeply in
holy affection. Who can describe the yearnings, the sighs,
the tears, they wept as they sat and talked of heavenly
things? Who can explain how they despised what is pass-
ing, and longed after what is everlasting? Let this be the
task of someone else: my job is to depict quite simply the
simple life of the virgin.

The virgin had a brother, Gregory, a monk of St
Albans, whom she loved with unusual devotion for the
grace of his manners, and the constancy of his belief.
Unless goodness and an inborn taste for holiness attract-
ed her to them, her relatives did not inspire much affec-
tion in her. Gregory having, with his abbot's permission,
stayed for a short time at his sister's hermitage, used to
say Mass there. But as the day came nearer on which God
had decided to snatch him from the cares of this world, he
was attacked by the sickness that was to end his life. His
sister, feeling deep love and compassion for him (she was
more staunch than anyone in loving the good), turned to
her usual resource – prayer – and pleaded with God to
reveal to her in his mercy what he intended for her
brother. The answer to her prayers took a long time, but
she would not give up, even though her brother's failing
health seemed to suggest that death was imminent. At this
Christina became terribly sad, and for the sake of her
brother moved Christ with floods of tears until she heard
a voice from heaven saying these words: 'You may be sure
his lady loves him.' And after a brief pause the voice went
on: 'And she loves you too.' Certain, therefore, and also
certain that her own death could not be long delayed, she
gave thanks to God because she had been heard but also

because both she and her brother had been summoned by the queen of queens.

Going to see her brother, she told him that he would be sent for by the mistress of heaven. And she went on: 'If some noble and influential lady in the world had called you to her service while you were in the world, you would have taken great care to respond graciously. Now that the mistress of heaven calls you, how much more should you obey her commandments to the best of your ability while you still can.' When Gregory heard this, realizing that his death was near, he strengthened himself with the sacraments of Christ, the more calmly since he now felt more certain he was about to die. And after he had received the viaticum, and everything to do with the funeral had been decently arranged, he was carried unconscious to the church in the presence of the abbot and the community of St Albans, accompanied by many weeping mourners. Full of hope he breathed his last, and, as he had earnestly hoped for long before, both his sisters, Christina and Margaret, were present at his burial.

In the year when Stephen was first elected king of England, he decided, on the advice of counsellors he trusted, to send ambassadors to Pope Innocent II in Rome, in order to receive the confirmation of his election from this supreme authority. The first, or one of the first, to be chosen to carry out this embassy was abbot Geoffrey. The king sent for him to give him his orders. He hurried to the virgin to ask her for her prayers. He told her about the king's summons, not yet knowing what it would mean. She, sadder than usual, said: 'Go with the grace of God. But you need to know now that this journey will not succeed. I do not have the confident feeling about you that

I usually have before God.' He went to the king's court, heard the royal decree about carrying out the embassy, and could not refuse. The thought of the journey itself was grievous, but the reason for it was just as grievous. He returned home to sort out the money for going. Once more he went to his divine refuge and discussed the task he was forced to undertake. He admitted his fear, and shed tears as a proof of his distress. He begged for two undergarments from her, not for pleasure but to wipe away the sweat of his travels. In spite of his worries, he begged her to pray the more earnestly to God for him, asking that his will in the whole matter might become clear.

She returned to silence with her face bathed in tears, her heart worn with sighing, and as she prayed continually both day and night, she heard a voice speaking to her from up above: 'Behold the wall.' And she saw a wall in which her beloved friend appeared to have been bricked up alive. 'As long', the voice continued, 'as he is firmly held in it, the protection of God will be his. But the garments which you have prepared to help him, give them at once to the poor, because Christ will find for him more fitting comfort for his journey.' Confident that this was a divine promise (for she was far from ignorant of these things), her tears turned into joy, her sighs into prayers.

In the meantime, the holy Thomas, whom the abbot had sent to some of the most influential people in the country, trying to obtain release from the embassy, found out that he was not with the king but already on his way to Rome. Returning from the court, he explained to the virgin that there was no reason to delay her beloved's departure. Everyone agreed that the abbot was the right

person to carry out the king's orders. But she said, 'I have been told, and I have seen, that there is no further reason for anxiety on his behalf.'

He believed her, knowing her reputation, and exclaimed, 'But I could still follow him and persuade him to come back.'

'On no account,' answered the virgin. 'I know now that he will not have to undertake it. All the same, I think it proper that the king's favour should be repaid with a gift from God.' In sending woven and embroidered presents (to the Pope) she fulfilled Geoffrey's command, while God, in protecting her beloved, confirmed the promise. She was glad to give away her handiwork so long as the man, whom true charity had crafted, was saved from embarking on a dangerous task.

In the third year of the reign of King Stephen a general council was called in Rome by Pope Innocent II. Apostolic letters ordering a convocation were sent all over the world, including England. At the time the Roman legate, Bishop Alberic of Ostia, happened to be holding a lawful council. When the papal mandate was received, a general discussion took place as to what should be done. And since it seemed unwise that, at a time when war seemed imminent, all the prelates of England should leave the country and make the dangerous crossing of the Alps, certain of the wisest men were selected to represent the English church. Among them the first to be chosen was abbot Geoffrey. He did not mind very much. He was well liked at the papal court and he looked forward to meeting old friends. All the same he wanted to have the virgin's approval of his decision, for he did not think Christina would neglect to pray to God about such an important matter.

Coming to see her, therefore, in a happy frame of mind, he told her that he was being sent to Rome on his own behalf and on the business of the English church. He could not refuse, especially since the papal mandate was urgent.

She was slow, as usual, in forming a reply, but in her heart she was unhappy about the undertaking. At last, suppressing a sigh, she said, 'Go in the Lord. For I know that whether you go or whether you stay, the divine will will be fulfilled in you. When I was praying I saw a kind of enclosure surrounded by high fences which were clear as glass. It all looked a bit like a cloister without door or windows, but it was round, and the grass in the garth was greener than ordinary grass. Delighted by this, I saw you, the object of my concern, inside this enclosure, standing enjoying yourself and having a very pleasant time. And when I wondered how you would get out of such an enclosure – by digging or any other method – a voice said to me, 'This enclosure before you has only one doorkeeper, God, and the man cannot go out or come in except by divine permission. For this reason, made strong in the mercy of Jesus Christ, I have a feeling that you will be kept within that enclosure and not allowed to set out on your journey.'

Geoffrey hurried to Oxford, where the king's court was being held, and Christina to the court of the eternal king to pray about the journey. At the king's court, discussions were held with the earthly king about the abbot's intended departure. With God, the celestial king, Christina wondered how the same man might be prevented from departing. She, who knew how to love to the greatest advantage, succeeded. She knew how to love because she

always prayed to God in every situation for a fair out-
come. By divine providence, contrary to what everyone
wanted and expected, letters were sent by the apostolic
legate to the Archbishop of Canterbury, Theobald, recall-
ing the abbot. And so the one who had seemed fated to set
out on the journey now joined with those left behind to
decide who should go. And he had to admit that the vir-
gin's pure heart had more power to influence events than
the political and selfish cunning of the powerful men in
the world.

That year King Stephen, at the wicked incitement of
some of his favourites, arrested two bishops who were
attached to the court, Roger of Salisbury and Alexander
of Lincoln. He felt that they were too powerful in wis-
dom, property, wealth, and family connections, and he
put them in prison, which showed a lack of respect for
their position and ecclesiastical status. On being ques-
tioned about this by Theobald, Archbishop of
Canterbury, and by some of his junior bishops, he gave his
word that he would accept the judgment of the church on
what was to become of them. On an agreed date they met
at Winchester. On the one hand there was the king with
his barons and followers, on the other the archbishop,
bishops, and abbots from almost the whole of England,
with a group of clergy to discuss such an important mat-
ter in the presence of the Roman legate, that is to say
Henry, Bishop of Winchester. The king was reminded of
his promise to accept the verdict, but he seemed unwilling
to accept any judgment on the matter if it was not
favourable to himself and his party. When he was asked to
show mercy on the prisoners he refused. Ecclesiastical
censure was then threatened, but treated with contempt.

In a word, the enemies of the church were trying to drive a wedge between king and clergy.

Suddenly the in a good mood, and you will come back to me happily next Thursday.'

He went on his way with joy, going to the court, and finding that everything turned out as he hoped. And on the day she had said he revisited his friend to thank her. He could not come earlier, much as he would have liked to, because he had been too busy, but now there was no reason to stay longer.

There was another thing about her which was remarkable and worth noting. Often, while she was speaking, she was caught up in ecstasy and saw visions that the Holy Spirit showed her. At times like that she felt and saw nothing of what was going on around her, or what was being said. When the things for which she asked God so earnestly were granted she received confirmations of it. Sometimes she saw Evianus (though not in the flesh) lightly touch her face and mouth with his first and middle finger, and at other times she felt what seemed like a little bird fluttering gently with its wings inside her breast. And when her mind was at rest sometimes she saw one, or more often three, lights shining with equal brilliance and splendour, so vividly that she felt, if any of her friends had been standing by, she could have shown the lights to them. Whichever of the signs she saw, it meant her prayer was granted. For these visions were neither imaginary nor dreams. She saw them with the true intuition felt by the mystics. Very often too, when she slept more deeply than usual as a result of her long vigils and total exhaustion, when it was time for Matins, she woke up so quietly and easily

that she disturbed nobody. But so assiduously did Christ watch over his handmaid that if any harassed her, they were visited with immediate punishment or suffered some physical ailment, so that we heard that one was struck down with blindness, another died without the sacraments, and others were destroyed by envy and lost the reputation for holiness which they had previously enjoyed.

But during this time, Satan, were your weapons blunted? Because you despaired of Christina, did you begin, because of Christina, to despair of destroying others? Not at all. The very same sort of perverse and corrupted people who accused Christ Jesus of casting out devils in the name of Beelzebub, and despised the disciples of Christ because they had women in the company, those sort of people, lacking any sense, did not appreciate the sweet odour of Christ coming forth from Christina. They only noticed the smoke. Victims of their own malice, yet spurred on by the envy of the devil, they endlessly gossiped about Christina, the lover of Christ, pursuing her with poisonous scandal and cruel words, and tried to ruin her good name, though she had patiently lived in seclusion. Some of them described her as a deluded dreamer, some a seducer of souls, others, more moderately, thought she was on the financial make. What had been gifts of God they thought were the fruits of earthly prudence. Others, who could think of nothing worse to say, suggested that she was attracted to the abbot by earthly love. In this way, though not agreeing among themselves, each of her detractors, according to his or her own evil fancy, persecuted her, although fortunately she was strengthened by the protection of Jesus Christ. All of

them found a perverse satisfaction in their tattling. If they could not deflect the virgin from her path, at least they could make many people believe scandal about her falsely.

As the good savour of Christ brings life to the good, so it brings death to the bad. But the savour of Christ is not easily spoiled. Of course, the common folk, who are fascinated by anything unusual, listened to the many rumours. Some in religious orders were pierced by darts of envy. Some of the monks and nuns gossiped about things that were neither true, nor remotely likely to be true, while others tried to dress their lies in a semblance of truth, so that listening to them you might think one was Jerome and the other Paula, had not one been celibate and the other the mother of a virgin.

Before their spiritual friendship had developed, the abbot's notable goodness and the virgin's holy chastity had been admired in many parts of England. But when their mutual love in Christ had led them to a greater good, the abbot was slandered as a seducer and the virgin as a sinner. There is nothing surprising in this since the devil, their adversary, feared the profit they would gain from each other, and the great good that would accrue through them to the church. He wanted people to believe that the very thing that had led to their extraordinary progress was the cause of their downfall. But all his attempts turned against him. Many of those who enjoyed attacking Christina's reputation came back, as we have noted ourselves, to the way of truth, confessing their sin, and obtaining pardon. Those who were false accusers later became true proclaimers of the truth of Christina's life. Some who had misunderstood the true situation, and

were uncertain about what was going on, were put right by God with ample evidence. This is shown by the following example.

In the monastery at Bermondsey, near the city of London, there lived a man admirable in his way of life, a true monk, living up to the sense of his name, Simon. He was sacrist of the house, and because of his holiness and his moral stature he was a leading member of the community. He had great respect for Christina. He took pleasure in their friendship, and spoke warmly of her, since he had found that after becoming a friend of hers he had felt a stronger sense of the Holy Spirit in his life. He was so offended by the gossips and slanderers that he silenced them as soon as they began to speak. But knowing that God champions just causes, he decided that he would ask him who sees the heart and is the knower of all secrets, to tell him the truth about Christina. And so he afflicted his body with fasting, and his spirit with watching and weeping. He slept on the stone pavement and would not lessen his hardships until the Lord answered him. For he considered it wicked to make false accusations against Christina, and he could not believe that he had been mistaken in his love for her.

God desired to put an end to his suffering and to show him, a lover of truth, the truth of the matter, so one day while the venerable Simon was standing at the altar celebrating Mass, lost in prayer, he noticed, with surprise, that Christina stood beside the altar. He was amazed at this, since the virgin could not have left her cell and it was unlikely anyway that a woman would be allowed to approach the altar. Stupefied, he awaited what came next. Then Christina said, 'You may be sure that my flesh is

without corruption.' And when she had said this she disappeared.

Full of joy and gladness he duly finished saying Mass, though he had not finished with the matter of the virgin. Finding one of the monks of St Albans, who happened to be at Bermondsey at the time, he sent a message to abbot Geoffrey by him explaining what he had seen and heard, and what he knew about the slandering of Christina. And as the monk was himself one of the ones who had slandered her, the Lord in his charity and justice arranged that through carrying this message he should know what he ought to feel about Christina. If he were to spread lies about her in the future, he would know beyond doubt that he was acting wrongly, and that he would receive the punishment due to back-biters. The venerable Simon did not know all this about the monk. When the abbot received the message from Simon he thanked God because he had mercifully revealed to others what he knew to be true himself.

Christina, who would not have known how to be crushed by the wiles of the devil, having already bested him so many times by her faith, pondered what new thing she could offer God both to give new vision to the abbot, and to silence the shamelessness of her traducers, whom she felt sorry for. So, being already endowed with the light which burns without consuming, she suggested offering a wax candle in the church as a gift every Sunday night. The suggestion was approved by the sisters, who knew nothing of the reasons for it. It was then Saturday.

The devil, aghast at the virgin's resolution, which he could not inwardly shake by any efforts he or his party might make, tried to scare her by putting on a monstrous

appearance. So, the next night, towards daybreak on Sunday, while Christina was in the monastery and while others were preparing for Matins, they saw a body without a head (for the devil had lost his head, that is to say, God), sitting in the cloister beside the entrance to the church. At this vision (women being timid creatures) they were frightened out of their wits and all of them fell prostrate at Christina's feet. One tried to hide her face in Christina's bosom, another hid under her veil, a third clung to her knees, another tried to hide at her feet, another hid under a bench, and yet another lay down on the ground, and shook as if the hour of her death had come. They all had one aim – to touch Christina's garments if possible. The devil, bold as always, burst into the church. At the sight of the monster the handmaid of Christ was naturally afraid, but, taking her courage in both hands, she prayed to the Lord, and with her prayers thrust forth the monstrous phantom. But for a while afterwards, she felt more than ordinary horror. Upset by this, she poured out prayers and lamentation to him in whom she trusted, fearing that if she was afraid of the monstrous appearances of the devil, it was a sign the Lord was abandoning her. But as she continued to pray about this, the message came: 'Your prayers on this subject are unnecessary. The prayers for your beloved friend, on the other hand, that he be bathed in eternal light, have been granted. You may trust that soon the perverse images, and the envy of your detractors, will disappear. For though it has been permitted for the devil to storm, and to sharpen the tongues of the spiteful in the world, you must not cease from doing good, nor be less constant in adversity.'

Taking heart from these replies and at the same time

delighted at the fate of her friend, she began to look more and more deeply into the depths of her heart to see whether one can love another more than herself, at least in those things which are connected with the love of God. And while she was brooding on this, one day when she prayed longer than usual in her hermitage, she felt such huge and sudden joy that she could make nothing of it, far less describe it. In a state of high elation, as she was talking lovingly with God, she heard this voice (not in the sound of words but in her mind) speaking in the tabernacle of her heart: 'The one you love so much for my sake, whose salvation you continually beseech, would you wish him to suffer death for my sake?'

Weeping silently in a great wave of pain, she replied immediately: 'That will I gladly desire, O Lord, and if your will required it I would even carry it out joyfully with my own hands. For if Abraham showed himself faithful to you in sacrificing his only begotten son, why should not I, if you command me, sacrifice my beloved for your sake? Especially as Abraham was attached to his son by a love which, though not opposed to you, was of the flesh, while only you understand the roots of the kind of love that binds me to my beloved. What death is more glorious than the one which is undertaken for the reason of love? What life is happier than that which is led with the help of grace?

While she went on with this interior and ineffably sweet conversation with God, she felt herself touched on her right side with a push which struck but did not hurt her, as if someone said, 'Look!' And as she looked towards the altar, she saw Jesus standing there in the loving attitude and bearing of one who has compassion for

sinners. Turning her eyes, she noticed her close friend for whom she had such concern, standing at her right hand, which was the Lord's left side. And as they knelt to pray, as the virgin's left was the Lord's right (for they were facing in opposite directions), anxious in case he should be at the Lord's left, she began to work out how he could be moved to the right, finding it unbearable that he should be at the Lord's left while she was on his right. For she knew that the right hand of God was the worthier place. She did not wish to be placed above her beloved, who was lost in prayer, but change places in some other way. Touched by this desire, she understood suddenly that the right hand was her possession, since she wanted God's love and mercy in everything and above everything. After that, in the many holy subjects which they discussed together, she used to say to her friend that there was only one thing in which one could not place another before oneself, and that was in God's love. One day a pilgrim, unknown to her but of impressive appearance, came to the virgin Christina's cell. She welcomed him warmly, as she did everyone, not asking him who he was, and not being told by him either. He departed, leaving behind a deep impression. Later he returned a second time. First he prayed to the Lord, and then he concentrated on the conversation with Christina. As they talked she felt a holy fervour which made her decide he was far beyond most men, or the merits of ordinary people. Immensely pleased at this, she invited him with kindly hospitality to share food. He sat down while she and her sister Margaret prepared the meal. Christina paid more attention to him, while Margaret was bustling about worrying over the meal, so that if it had been Jesus sitting there you would see

another Mary and Martha. When the food was ready, he raised bread to his mouth and seemed to eat. But if you had been there you would have noticed that he tasted rather than ate. When he was invited to enjoy a little of the fish on his plate, he replied that he needed no more than enough to keep body and soul together. As both of the sisters were thinking what beautiful features he had, what a fine beard, what an imposing appearance, and what well-chosen words, they felt such spiritual joy that it seemed to them as if they had an angel before them rather than a man, and, if their virginal propriety had permitted, they would have invited him to stay with them.

However, after blessing them, and saying goodbye, he set off, still known very little by the sisters. But he left a deep impression on their hearts, one of great sweetness, and often when they talked together they would remark, with sighs that expressed their feeling, 'If only our pilgrim would come back and we could enjoy his company again! If only we could look at him and learn from his fine and noble character!' With such comments they increased each other's longing.

Christina, brooding on this, prepared for the coming of the feast of Christmas, uncertain where such longings would lead her. On the day before the vigil of the feast, she was in bed with an illness, and so feeble was she that she could not attend church on the vigil. Two pious monks, hearing about this, decided to pay her a visit out of kindness. And while they chanted the hours of the Christmas vigil to the sick woman, she heard and remembered, along with all else, the verse of the hour of None, that special pleasure of a special feast – 'Today you shall know that the Lord will come and tomorrow you shall see

his glory.' Realizing the significance of the verse, she was so thrilled by joy that for the rest of the day and the next night thoughts like this kept running through her mind: 'At what hour will the Lord come? How will he come? Who shall see him when he comes? Who will deserve to see his glory? What will that glory be like? How great? What and how great will be the joy of those who see it?'

Fastening her mind on holy desires in this way, severely sick and confined to bed, she prepared herself for the hours of Matins. And as she heard the anthem of the feast Christ is here, she understood that she had been invited to the joy of his birth. Her sickness vanished and she was filled with such spiritual joyfulness that she could think only of holy things. When the rest sang the hymn 'We praise thee, O God', her attention wandered, and she felt as if she had been transported to the church of St Albans, and stood on the steps of the lectern where the lessons of Matins are read. Looking down on the choir, she saw someone in the middle of the choir enjoying the singing of the monks. His beauty is beyond my gifts and ability to describe. He wore a golden crown on his head thickly set with precious stones which seemed beyond the skills of any human craftsman. It was surmounted with a cross of gold superbly wrought, made not with human hands but by divine skill. On each side of his face a band or fillet hung from the side of the crown, glittering and fine, and the jewels themselves shone with what looked like drops of dew. In this way appeared the one who had only to be seen to be loved, the fairest of the sons of men. Feasting her eyes on this beauty, Christina felt herself caught up into another world. Whether she saw what she saw in the

body or out of the body, God is her witness she never quite knew.

On Christmas morning, when it was time for the procession, a message came to her that the beloved pilgrim had arrived. When she was told, she was beside herself with joy, as if embers had burst into the flame of desire. For she knew how much she had to gain spiritually by entertaining, in the person of the pilgrim, the Christ whose presence had brought her such sweet relief. She ordered the closing of the doors.

The pilgrim followed the procession of chanting sisters. His natural gait, his strong expression, his fine appearance, were noted, an example of graceful humanity. As it says in scripture, 'I will give you thanks in the great congregation.' The pilgrim took part in the procession and the Mass and the other parts of the service. When it was over, the virgin of Christ left the church first so that she should be the first to greet him as he came out, for she could not see too much of her pilgrim. There was no other exit except the one at which Christina waited.

When everyone had come out, she asked, 'Where is the pilgrim?'

'He is praying in the church,' they answered. Impatient from waiting, she sent some of the nuns to call him. But they came back to say that they could not find him anywhere. Disturbed and astonished, the virgin asked for the key of the door.

'Here it is,' said the one who was in charge of it. 'But from the time that Mass began no one could have come out, since the door was closed and I was holding the key.' Nor had anyone seen the pilgrim come out of the church. Who else shall we say that this man was, unless either an

angel or the Lord Jesus? The one who appeared that night, looking as he did, revealed himself in a similar way to the way he will be seen in glory. This is the way glory appears to us in the life we lead now, seen only as if through a glass. For example, God is said to dwell in darkness, not that he really dwells in darkness, but because the brightness of his light blinds those of us still imprisoned in the body. On that day he chose to appear in the guise of a pilgrim, of Jesus the way he looked when he was grown up.

However, nothing is lacking to those who follow God, who love him in truth. Behold, O Lord, you desire truth in the inward parts, and in the hidden places you will teach me wisdom. Among the wise your handmaid Christina was pre-eminent. The closer she came to you in pure love, the more she understood the secrets of your wisdom with her pure heart. So you gave her the power to know the secret thoughts of men, and to see those that were opaque as clearly as those that were transparent.

This was obvious in what follows. One of Christina's nuns was thinking of doing something or other secretly, and the handmaid of God, seated in another house, saw it through the walls and forbade it, saying, 'Don't do it! Don't do it!'

The girl said, 'What, mistress?'

Christina said, 'What you were just thinking of doing.'

'But I was not thinking of doing anything that I should not,' said the girl.

Then Christina called her to her, and whispered in her ear what she knew had been thinking in her heart. When she heard the whisper the girl blushed with shame, so proving that what was said was true. Then she begged and

implored Christina for the sake of her good name not to tell anyone, because she could not live with the shame of it if it came out.

Another time, as we were having a meal with the hand-maid of Christ, the same girl put food on the table for us to eat. As we ate, Christina refused to have any. When we asked her to take food with us, she summoned Godit, for that was her name. Christina asked her, gently, out of respect for the guests, if she had made the salad from ingredients she had been forbidden to use. Christina had said firmly that she would eat nothing from the garden next door because the owner, out of meanness, had denied her a few stalks of chervil when she had recently asked for them. Meanwhile she accepted the salad, but refused to eat it, and after the meal, confirmed the girl's guilt from witnesses who had seen her pick it. The girl then admitted that the salad had been gathered in the forbidden garden.

The virgin had a friend who loved her very much. She sent her servant to see him with some things he might find useful. But the servant stole some of them during the course of the journey and used them for his own selfish ends. When the virgin became aware of this in the spirit, she confronted him, and rebuking him without anyone else being present, cleansed him of his sin.

Christina had a sister called Matilda who lived in the world. When she and her husband were in bed one night at Huntingdon where they lived, Christina, in her cell, saw and heard them talking, so that later when they came to visit her, she was able to tell them exactly what they had said to each other, when and where. Both of them admitted to me that it happened just as she said.

Most of Christina's thoughts were with her dear friend Abbot Geoffrey, whom we have mentioned earlier, night and day, and she immersed herself in his interests by fasting, watching, calling upon God, the angels and saints and others in heaven and on earth, requesting the mercy of God in humble prayers, wisely chiding him when his deeds were less than perfect.

THE MARTYRDOM OF PERPETUA
Sara Maitland

The story of Perpetua, a young mother who died for her beliefs in the arena at Carthage in AD 203, is deeply moving – and far too little known except by scholars.

Perpetua wrote a graphic account of her arrest, the reasons for it, and her feelings as she lay in prison, unable to feed her new-born baby and awaiting an horrific execution. She is the first Christian woman to write about the world as she saw and experienced it, and is amongst the earliest female writers of any kind known to us today. Fortunately for us she was a gifted writer, with a vivid descriptive style.

After her death, her Christian companions finished the story, describing the courage and suffering with which she and her maid Felicity faced the beasts of the arena.

Sara Maitland, novelist, journalist and feminist, writes with wisdom and compassion about this early martyr.

Also in this series

THE TRIAL OF JOAN OF ARC
Marina Warner

The legend of Joan of Arc – the simple shepherd girl relieving the siege of Orléans and crowning the Dauphin king at Reims – is well known. Less well known are the details of her trial in 1431, at which, although she conducted herself with extraordinary dignity and intelligence, she was condemned to death by the ecclesiastical and political establishment in a legal process distorted by the bitter civil conflicts of the Hundred Years War. The record of her trial makes clear that her insistence on cross-dressing – a threat to the establishment which counted for more than her military achievements – was a prime cause of her sentence.

Marina Warner, Reith lecturer, and author of *Alone of All Her Sex, Joan of Arc* and *From the Beast to the Blonde*, introduces a transcript of the trial with a penetrating examination of the reasons for her condemnation and of the role Joan of Arc has played in the Christian imagination.

Also in this series

FLORENCE NIGHTINGALE:
LETTERS AND REFLECTIONS
Rosemary Hartill

The example of Florence Nightingale, the 'Lady with the Lamp', has often been used to encourage girls to lead lives of selfless service. She was not, however, a sweet or amenable woman, and she did not share the ideals of many of those who have recommended her – for example, she thought the family, so much idealized, was a dangerous trap, and noted that Jesus Christ took a similar view.

She was a kind of genius – enormously intelligent, meticulously educated by her father (she made annotations in her Bible in Hebrew and Greek), and with a practical flair that was her great gift to the world and which continues to influence hospital design and the care of the sick until this day.

Some received ideas about her – for example that her long illness after the Crimea was neurotic in origin – now look unlikely. She had very unconventional ideas about religion, and an acerbic and impatient way of stating them.

Rosemary Hartill, well known for her religious broadcasting and journalism, takes a new look at an old heroine.

Also in this series

EMMA LAZARUS
Emma Klein

'Give me your tired, your poor,
Your huddled masses yearning to breathe free,
The wretched refuse of your teeming shore.
Send these, the homeless, tempest-tost to me,
I lift my lamp beside the golden door!'

These lines are famously engraved on the pedestal of the Statue of Liberty. They were written by the nineteenth-century American Jewish poet Emma Lazarus. Well educated and of wealthy Sephardic ancestry, she was encouraged by her parents to become a writer, and her poetry and translations of French and German classics were published, and admired by Ralph Waldo Emerson, among others. In her mature work, perhaps influenced by the brutal pogroms of Jews in Russia, she wrote a great deal about Jewishness and the struggle of Jews to survive in anti-Semitic societies. On a practical level, she visited Jewish immigrants awaiting entrance to America in their refuges on Ward Island, and worked hard to make life better for them once they became citizens. In her vision of a homeland for the Jews in Palestine, and her fears of a darkening future, she was strikingly prophetic.

Emma Klein is a freelance writer and journalist. She contributes regularly to *The Tablet*, and is the author of *Lost Jews* (Macmillan).